ALLOA AND THE HILLFOOT VILLAGES

THROUGH TIME

Walter Burt

AMBERLEY PUBLISHING

Acknowledgements

A lot of the older images used in the book are from my own collection, but others have been supplied by Ian Chalmers, Tom Douglas and Robert Thomson, whose love for 'The Wee County' is truly unquestionable, and to these gentlemen I am eternally grateful. My thanks also to Ann Callaghan for the use of the lower image on page 29 which shows the piers of the old railway bridge which crossed the River Forth at South Alloa. All recent, present day photographs were taken during the summer of 2013.

I must once again, thank my lovely wife, Lisa, and our children, Helena and Callum, for putting up with my days of neglect towards them, as well as the days of encouragement from them.

Dedicated to my wife Lisa, and my children, Helena and Callum. Also for my uncle, Bert Duncan, of Sauchie.

First published 2013

Amberley Publishing
The Hill, Stroud
Gloucestershire, GL5 4EP

www.amberley-books.com

Copyright © Walter Burt, 2013

The right of Walter Burt to be identified as the Author of this work has been asserted in accordance with the Copyrights, Designs and Patents Act 1988.

ISBN 978 1 4456 2060 2
E-Book ISBN 978 1 4456 2067 1

British Library Cataloguing in Publication Data.
A catalogue record for this book is available from the British Library.

Typeset in 9.5pt on 12pt Celeste.
Typesetting by Amberley Publishing.
Printed in the UK.

Introduction

I was totally amazed and surprised by the vast amount of old postcards that were still available that had originated from Alloa and the Clackmannanshire villages since the early 1900s. It made the task of selecting the final images for the book that little bit harder, as I felt I was spoilt for choice in the end. This book could so easily have been two, three, or even four times larger, for there is so much to see, and so much has been documented and recorded that I was loathe to omit such a large variety of other available images.

Although it is the smallest county in Scotland, measuring approximately 61 square miles, Clackmannanshire, affectionately known as 'The Wee County', has so much hidden history and many places of interest. In terms of population, it is the smallest council area in mainland Scotland, with a population of almost 50,000, around half of whom live in the main town and administrative centre, Alloa. The motto of Clackmannanshire is 'Look Aboot Ye.' This is in reference to the legend that Robert the Bruce mislaid his gauntlet (mannan) on a rock (clack) while in the area and, on asking where it was, was told, 'Look aboot ye.' This is also self explanatory as to the origin of the name of the county. The county's coat of arms shows a pair of gloves over a red Saltire on gold. The red Saltire on gold is from the Bruce family arms. The gauntlets and Saltire refer to this legend, as does the motto.

In 2007, a re-branding exercise led to the area adopting the slogan 'More Than You Imagine.' Of all the industries found within its boundaries, Clackmannanshire became well known for the many weaving mills powered by the burns originating in the Ochil Hills. Other local industries have included brewing, glass manufacture, mining and ship building. Now capitalising on its location in the central belt and its transport links, Clackmannanshire attracts service industries and tourism. I hope to touch upon one or two of the interesting places in the locations covered within the book.

I have started by having a look at Alloa. This was not just because it is the administrative centre for the county: you will find that the images in this book are done alphabetically, so Alloa seemed the obvious place to start. It should also make it easier to find your way around the pages. Please note that the spelling on some of the older postcard images may differ from the way they are spelt today.

Alloa

(Scottish Gaelic: *Alanhagh*, meaning 'wild or rocky plain')
Alloa is the largest town in Clackmannanshire, sitting on the north bank of the River Forth with the Ochil Hills forming a rather impressive background. It was first mentioned as a port in 1558, when it was recorded that coal was being transported to the island of Inchkeith, further down the Forth Estuary. Roads in this area at the time were few and far between, and were probably in very poor condition, making it cheaper and faster to travel by boat when delivering cargoes to the town. A ferry service across the River Forth had operated between what later became South Alloa and Alloa since the early medieval period. By 1939 these ferry services had ceased operations as they could not compete with the Kincardine Bridge which had opened just three years previously further downstream.

Under the Earls of Mar, Alloa also began to develop as a significant harbour and trading port. The main trade at the port up to the eighteenth century was tobacco. It was brought overland on packhorses from Glasgow after arriving from America, and sold in London, destined for the Netherlands, Norway and other European countries. This tobacco was known as 'Alloa Pigtail'. Alloa's involvement in the tobacco trade ended when the Forth & Clyde canal was built in the 1790s. From the eighteenth century, the chief export was coal, destined mainly for America. Ships usually returned carrying new wooden pit

props for the local mines. By the 1960s, the port at Alloa was struggling to compete with the other ports found further downstream, mainly at the more modern Grangemouth with its newer, modern handling techniques. Alloa port finally closed in 1970 and since then, the economy of the town has been centred mainly on retail and leisure.

Alloa is also well known for its brewing and glassmaking industries, but these industries too have suffered in recent times. After the closure of the main industries in the town, only one brewer and one glassmaker survive today. Another industry that was important to the town was weaving; in particular it was in the manufacture of knitting yarn. Patons & Baldwins was formed in the 1770s when John Paton of Alloa merged with James Baldwin of Halifax, England. They produced yarn mainly for commercial knitting machines. The Paton family were regarded as generous benefactors in Alloa, where they provided funding for a significant range of public building projects, including the town hall, public libraries, a school, a swimming pool and a gymnasium. Yarn production at the sizable Patons & Baldwins mill in Alloa ended in 1999.

Alloa was also an important link within the transport network in Central Scotland. One of the earliest transport links in Alloa was the 'Alloa wagonway'. The Earl of Mar built this wagonway in 1768 to transport coal from his coal mines near Sauchie, north of Alloa, to the dockside at the River Forth. It was originally constructed with wooden rails, but by 1810 these had changed to cast iron. Along with other similar wagonways in Central Scotland, it played a pioneering role in the development of rail transport in Scotland.

The railways proper reached Alloa in 1850, when the Stirling & Dunfermline Railway Company reached the town from Dunfermline. The following year, lines had also been laid to Alloa Harbour and Tillicoultry. Passengers for Stirling used to cross the River Forth on the ferry to South Alloa and connect with the railway on the south side of the river for onward travel to Stirling. It was the following year again (1852) when the line reached Stirling. In 1853, a swing bridge was built across the Forth linking Alloa to the Scottish Central Railway at Throsk. Alloa station closed to passenger traffic in October 1968 and by 1970 had closed for freight traffic too. A large part of the former station site was subsequently utilised for building the new leisure centre.

Alva

(Scottish Gaelic: *Allamhagh Beag*, meaning 'little plain of the rock')
From west to east, Alva is the third of the small towns and villages that dot along the southern edge of the Ochil Hills. Alva developed as a textile weaving town when the industrial revolution reached this part of Central Scotland. In a similar story to the other towns and villages in the area, it was the woollen mills which provided work for the local townsfolk and the local immigrant workers too. The power for the mills came from the burns running down from the Ochil Hills along the length of the Hillfoots. Alva is also home to the 'Mill Trail Centre', housed in the old Glentana Mill, next to Cochrane Park. It is home to a permanent exhibition about the local weaving industry and its conditions, and the experiences of those who worked in it. The famous and spectacular Alva Glen is situated to the north of the town and follows the course of the burn running through it. Between 1937 and 1954, the Glen was famed for its illuminations, which drew visitors from all over Scotland and beyond. The illuminations were revived in 2004. Alva has two parks adjoining each other, Cochrane Park and Johnstone Park. Cochrane Park is the home of Cochrane Hall, a well known and popular local place which has recently received an extended refurbishment. Johnstone Park once had a popular boating pond, but this has now been filled in and an extensive children's play area is now located there. The park is also home to Clackmannanshire's last highland games event, the famous Alva Games, held every second Saturday in July and now over 150 years old. The most prominent building in Alva is Strude Mill, a former woollen mill that has been restored and converted into flats. It stands above the town at the base of the hills, and is clearly visible from some distance away.

Blairlogie

(Scottish Gaelic: *Blàr Lagaidh,* meaning 'the field or plain of Logie')

Blairlogie is the first of the villages and is also the smallest. It sits at the base of Dumyat Cliff and is one of the earliest conservation villages in Scotland. Any visitor to Blairlogie will certainly love the little cottages from between the seventeenth and nineteenth centuries which mainly comprise the village. One of its features is the small burn which winds its way through the streets in a stone walled culvert. It is known that between 1598 and 1609, the minister of Logie Parish was Alexander Hume, the Scottish poet. Kenny Logan, the famous Scottish international rugby player, used to live in the village and several of his relatives still live in the area. Because it is the smallest of the villages, it is thought that the population will be less than one hundred inhabitants.

Dollar

(Scottish Gaelic: *Dolair,* meaning 'haugh place')

Numerically the fifth town along the base of the Ochil Hills, and perhaps the most well known of the Hillfoots towns and villages. One of the more famous of Dollar's buildings is undoubtedly Castle Campbell, lowland seat of the Duke of Argyll, and where Mary, Queen of Scots, once lived in the sixteenth century. The castle is accessed through Dollar Glen, a wooded valley traversed by various tracks and paths in an area excellent for walking. At the foot of Dollar Glen there is The Mill Green. Here there is also a small museum, run by volunteers, which contains an interesting collection of local items and much information about the former Devon Valley Railway, which closed to passengers in 1964. The famous and picturesque Devon Valley line ran from Alloa to the junction at Kinross, and then northwards to Perth. The former railway platform is still in situ and the track bed has now become part of a walking and cycling track known as the Devon Way. Similarly to the other Hillfoots villages, the textiles industry played an important part in the town's development. Another of Dollar's famous buildings is Dollar Academy. It was founded by John McNab, a local wealthy merchant, after he left Dollar to seek his fortune on the high seas. He styled himself into both a captain and a successful merchant, amassing a millionaire's fortune before his death in 1802. He bequeathed £65,000 to found 'a charity or school for the poor of the parish of Dollar where I was born'. Dollar Academy, an elegant colonnaded building, was built 17 years later and because of this school the town draws young and reasonably well-off families, giving it a slightly different character from the other Hillfoots Villages. Bus services provide links to the county town of Alloa and onwards to Stirling. St Andrews can also be reached directly by bus but with an infrequent service.

Menstrie

(Scottish Gaelic: *Meanstraidh*)

The second of the Hillfoots villages, situated near to the foot of two of the Ochil's western hills, Dumyat and Myreton. Like the other villages along the base of the Foothills, at the northern end of the village lies Menstrie Glen, the source for the Menstrie Burn that runs through the village. Although generally tranquil, the burn drains a rather large catchment area of approximately $14km^2$ from the Ochil Hills. This has led to occasional flash flooding in Menstrie. The last occasion was in August 2012, when the burn overflowed its banks and thirty-eight elderly residents of Menstrie House had to be evacuated to other care homes within the region. Menstrie was home to two mills during the industrial revolution, the Elmbank and the Forthvale mills. These mills were situated on either side of Menstrie Burn. The Forthvale mill no longer stands, but the Elmbank mill is still in use today as small business units

and offices. In the early 1860s, a group of local mill and distillery owners got together to form the Alva Railway Company. This short branch line left the North British Railway's Stirling to Alloa line at a junction near Cambus, and ran through Menstrie to the terminus at Alva. The branch closed to passengers in November 1954 but the line stayed in use, serving the DCL factory until the mid-1980s. Today, nothing remains of the platform or station buildings at Menstrie, or of the branch line that served the yeast producing factory. Bus services run frequently to and from Alloa and Stirling, and less frequently to St Andrews in Fife.

Muckhart

(Scottish Gaelic: *Muc-Àird,* meaning 'pig height')
Muckhart is commonly known to be the sixth and final village of the Hillfoots at the far eastern extent nearest the final hill, Seamab. Muckhart is actually the name for two villages, Pool of Muckhart and Yetts o' Muckhart. The name 'Muckhart' may derive from the fact that the area was once extensively used for pig farming. Up until the county boundaries were reorganised in 1971, Muckhart could be found on the southernmost tip of the county of Perthshire. It seemed to make more sense to transfer it to Clackmannanshire and it has since been part of Central Region. Muckhart makes an ideal location from which to start exploring the Hillfoots or southern Ochil Hills. The 'Muckhart loop' is a popular walk in the area. This route will take you through the forests and flowers of Geordies Wood, which is part of the Muckhart Nature Park. Both of these conservation villages have well-looked-after buildings of note from the eighteenth and nineteenth centuries. There you will find a coaching inn and a tollhouse which was used by stage coaches and cattle drovers. One of the earlier buildings at Muckhart was Cowden Castle. Included in the castle estate was a Japanese garden which, unfortunately, has now returned to nature, having been abandoned in about 1960. A fire ravaged the castle in 1950 and it was decided to demolish it two years later. Many of the valuables from the house survived and were removed to Arndean. Many other items of furniture were distributed among the many estate houses and thereafter the estate was merged into the Arndean Estate. In common with the other villages, Muckhart also had a mill, and to this day has one of the finest, largest, overshot waterwheels, powered by the burn emanating from the hills beyond.

Tillicoultry

(Scottish Gaelic: *Tullach Cultraidh,* meaning 'the mount or hill at the back of the country ')
Tillicoultry is the fourth village, or small town, on the route starting from the east of the Hills. As mentioned already, the Industrial Revolution in the nineteenth century didn't just change the way industry worked, it changed people's lives dramatically. Because the work was there, Tillicoultry became overcrowded; there was poor housing, drainage, and an inadequate water supply and the infant mortality rate grew. To address these problems, Tillicoultry Burgh was created in 1871. One of the first bus stations in the country was built at Murray Square in the town in 1930 to help regulate the 334 bus journeys through the town daily. Despite the apparent decline in public transport and ever-increasing car ownership, Tillicoultry, as well as all the other Hillfoot Villages, still retains a regular, frequent bus service. Tillicoultry was connected to the rail network in 1851 when the Stirling & Dunfermline Railway reached the town from Alloa. The through connection to Kinross was made in 1871 and the completed line was known as the Devon Valley Line. It was the motor car which brought about the demise of the Devon Valley railway when the line closed to passenger traffic in 1964 due to falling passenger usage. It closed to freight in 1973 after Dollar Mine closed and the track was uplifted. Today, Tillicoultry, or just plain old 'Tilly' to the locals, is home to the Sterling Mills Retail Village. Like the other Hillfoot villages, the local workforce now make their way to places like Alloa and Stirling for employment, although the villages themselves are also tourist attractions.

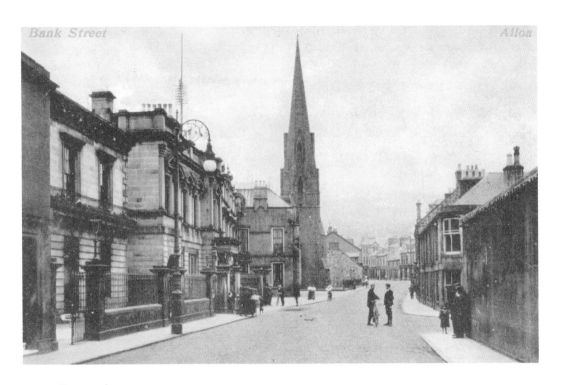

Alloa, Bank Street
Not much has changed to the rather grand looking buildings in the foreground up as far as the church. Beyond that, there are more modern buildings on view in the distant part of the street on the right hand side. The church, formerly Chalmer's Church, is now in use as a nightclub.

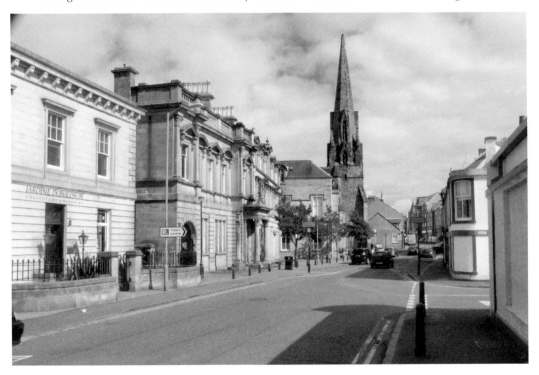

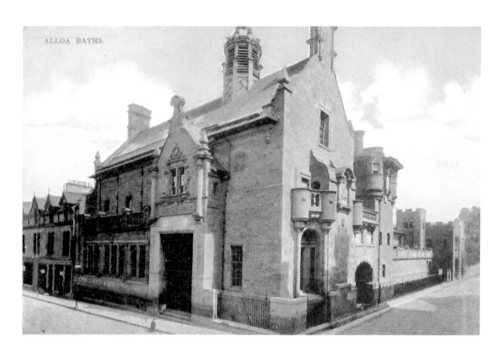

Alloa Baths

Also known as the 'Spiers Centre' or the 'Batus Hall', it was designed in 1895 by Sir John James Burnet but was paid for, and donated to the town by, local mill owner and philanthropist John Thomson Paton. The Turkish baths were destroyed in 1966 following a fire during a refurbishment. The swimming pool was closed in 1986 but was reopened in 1998 after being converted to a gymnasium. The building was renamed the Spiers Centre after Tommy Spiers, a local boxer who trained in the gym and who won the Scottish lightweight title from 1932–34. It is in the process, once again, of receiving a refurbishment.

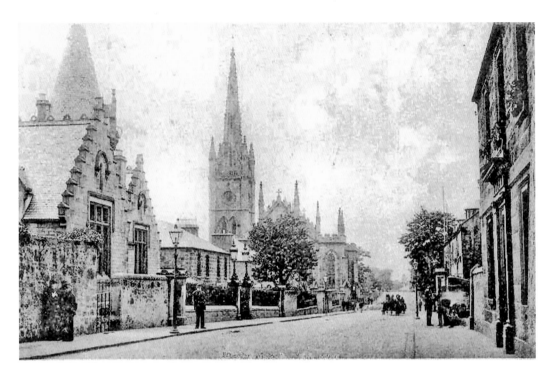

Alloa, Bedford Place 1

The building on the left of the old postcard image was in use as a school and assembly rooms when the postcard was issued. The parish church building still dominates the skyline today. The Royal Oak Hotel stands adjacent to the private dwelling houses sandwiched between the school and the church in the old image and is still standing proud today.

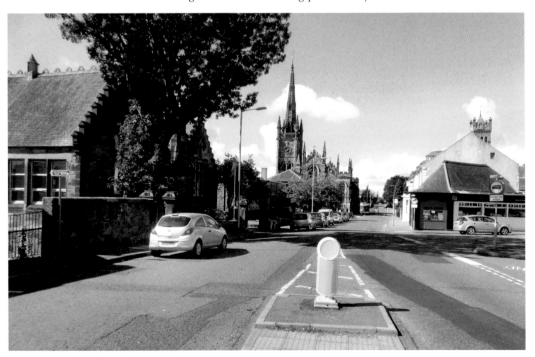

Alloa, Bedford Place 2
We are still within Bedford Place but now looking towards St Mungo's church from the western end. The first religious building on this site is thought to have been a chapel dedicated to St Mungo in the fourteenth or fifteenth century. The current church was opened in 1819 and has seating for 1,561 members of the local parish.

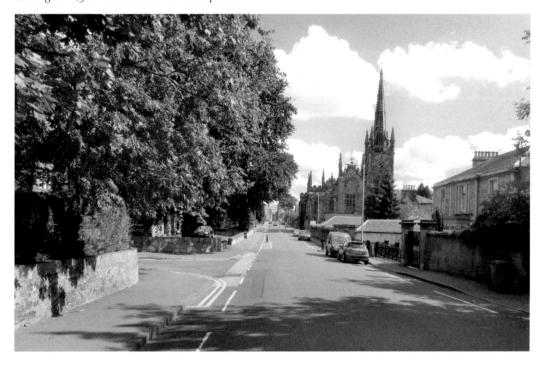

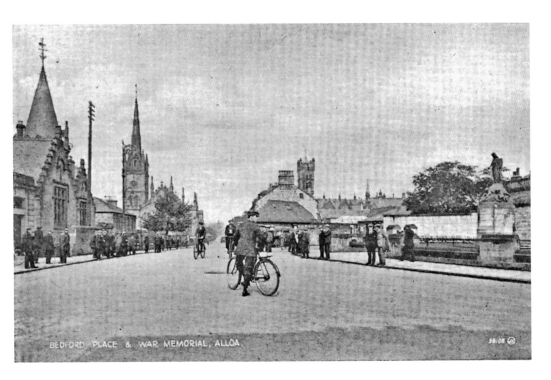

Alloa, Bedford Place and War Memorial
This image has been included to show the location of the war memorial in relation to the street layout in the area. The memorial sits on the corner between Church Street, Bedford Place and Bank Street and depicts St Margaret in full regalia, standing guard over three Allied soldiers, presumably in the trenches during the Great War.

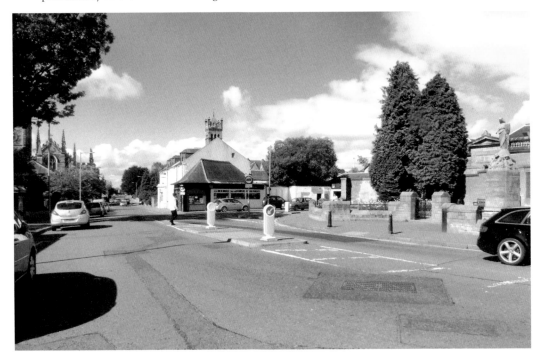

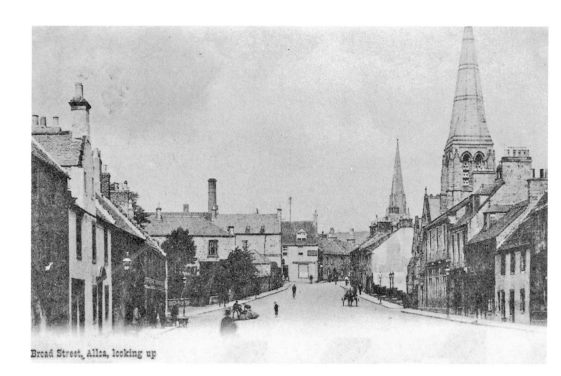

Broad Street, Alloa, looking up

Alloa, Broad Street

Looking up near to the top of Broad Street much has changed regarding the buildings on the left of the images. Only the spires of St John's on the right hand side and the distant spire of Chalmers Church remain, along with the building immediately before St John's church. St John's church was previously located in the town's Clackmannan Road.

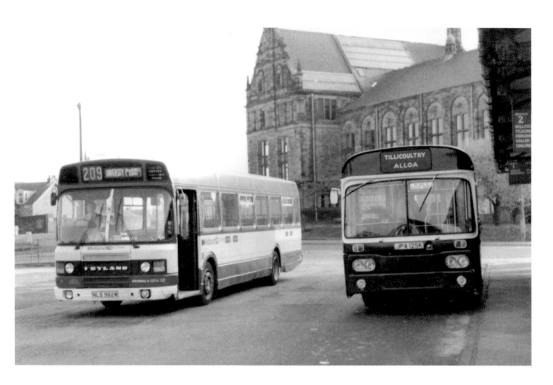

Alloa Bus Station 1

Looking from the bus station on 1 May 1984, with the Town Hall in the background, we find bus JPA125K having just arrived from Tillicoultry. This was one of Mackie's buses, acquired to operate Halley's former Alloa to Tillicoultry service. Mackie's had taken over Halley's business and had painted this bus in the traditional Halley livery. Today, the bus station area is now the location of the local police station.

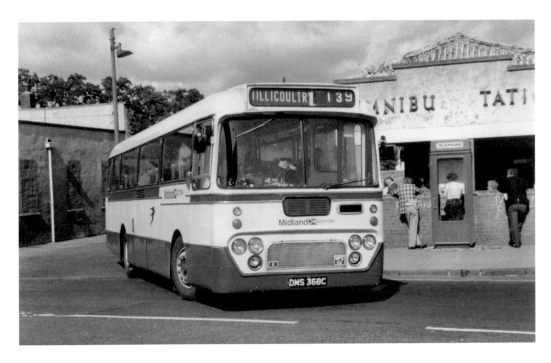

Alloa Bus Station 2

Seen leaving the bus station in Alloa during August 1981, we find Leyland Leopard DMS368C (MPE82). This had Walter Alexander's famous Y-type of coach body and was a local bus stationed at Midland's Alloa depot. This area is now the home of the town's police station and 'Peppe's', a local public house. Given the amount of traffic using the town centre today, and with hindsight, it may have been better if the bus station was still here today.

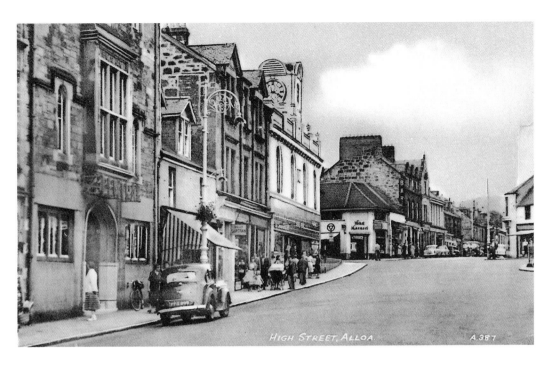

Alloa, Central Picture House

Despite only being a small town, Alloa was blessed with having three cinemas in the town centre. One such cinema was the Central Picture House, situated almost half way up the west side of the High Street. It began as a picture house in 1912 and operated until it was destroyed by fire in 1925. It was rebuilt the following year and finally closed its doors in 1962. It had previously been known as the Picturedrome. The location is now occupied by a clothes shop.

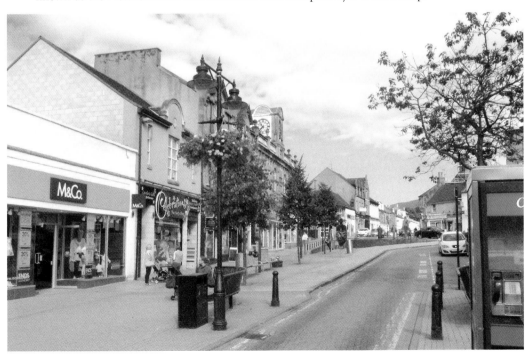

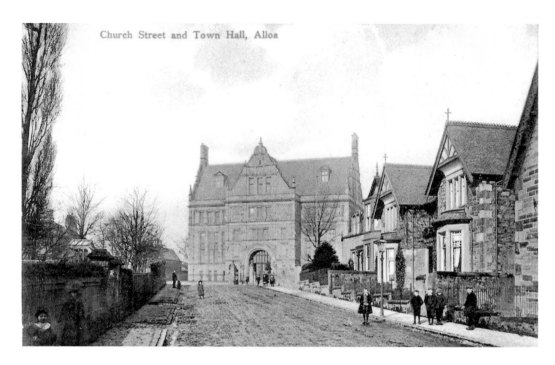

Alloa, Church Street and Town Hall

When looking up Church Street towards the town hall, it seems that not much has changed over the last century. There have been some modern flats erected near the top of the road on the left, and stretching down Marshill. In the old image, you can just make out the tracks left by numerous carts, presumably horse drawn as Church Street sits on a small incline. The overhanging trees on the left of the street are now quite dominant compared to the postcard image taken nearly a century ago.

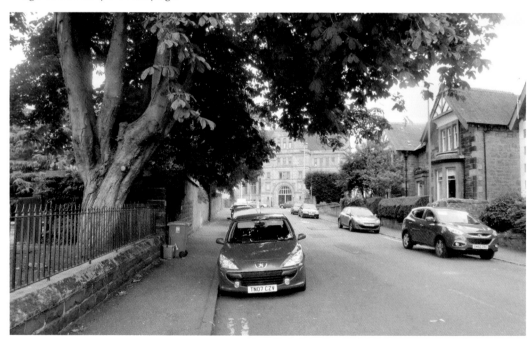

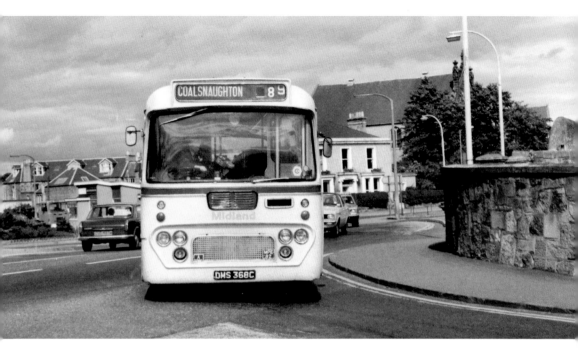

Alloa, Church Street Top

Not much has changed to the buildings shown between the two photographs, taken almost thirty years apart. The roundabout and surrounding roads have been slightly widened, and there seems to be more in the way of road signage nowadays. The bus in the older photograph is a Walter Alexander bodied Leyland Leopard (MPE82) belonging to Alloa depot, and is seen on a local service 89 enroute to Coalsnaughton.

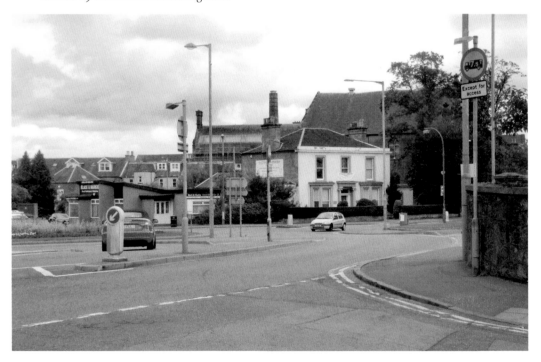

Alloa, Clackmannan Road

The building on the left is another religious building dedicated to St John. This was St John's Episcopal Chapel, which was not a large building but still had seating for 350 local worshippers. This building was replaced by a newer church located near the top of Broad Street in 1869. The dwelling houses on the bend at the top of the small incline can still be seen standing there at present.

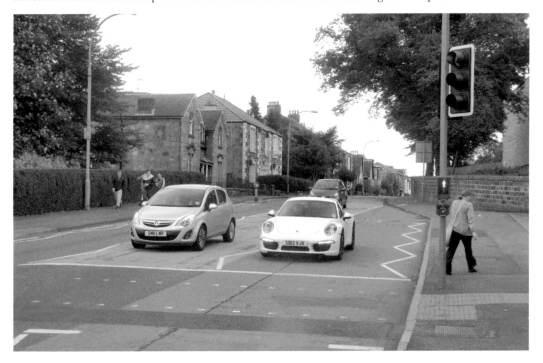

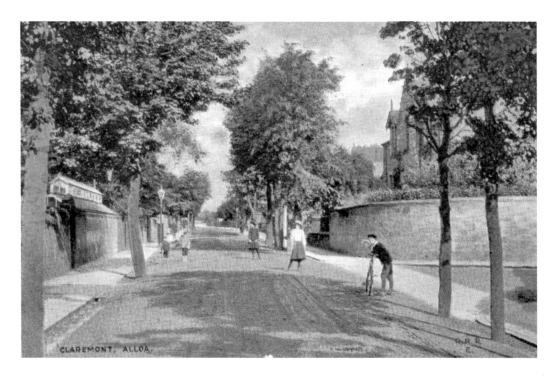

Alloa, Claremont

The view looking westwards along Claremont from its junction with Fenton Street has changed dramatically over the last century. The street, at this location anyway, seems to have been lined with trees. I can understand how impractical it is nowadays to have such a thing as trees at the side of the road, but I must admit it does look more aesthetically pleasing.

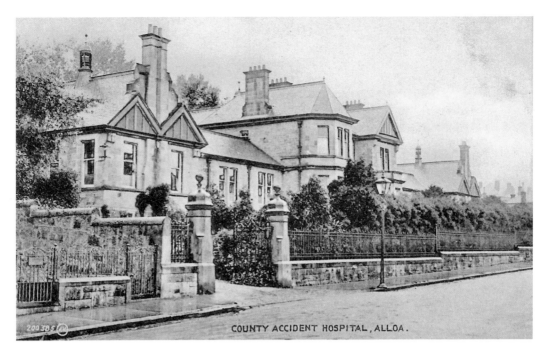

COUNTY ACCIDENT HOSPITAL, ALLOA.

Alloa, County Accident Hospital

This hospital building, previously called Alloa Cottage Hospital, was founded in 1868 and was situated in the town's Ashley Terrace. Latterly called Clackmannan County Hospital and run by NHS Forth Valley, it has now been demolished and the site lies empty, awaiting further development. The original gate pillars are all that remain to identify the site of the original hospital building.

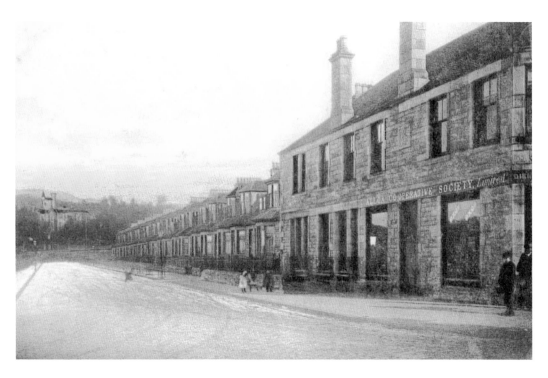

Alloa, Dirleton Gardens

Looking northwards from the junction with Smithfield Loan, we see that not a lot of change has happened to the houses lining the street on the right hand side. The major change has been to the local Alloa Co-operative Society store in the old postcard. In keeping with the times, this old building has been converted into flats. Better that than lying empty and going to ruin, I suppose.

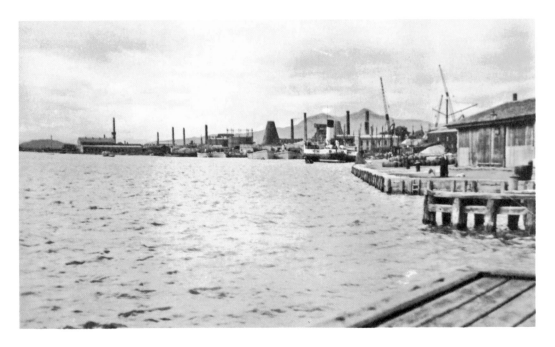

Alloa Docks
Alloa was first recorded as a port in 1558, when it was recorded that coal was being transported to the island of Inchkeith further down the Forth Estuary. Roads in this area at the time were few and far between, and were probably in very poor condition, making it cheaper and faster to travel by boat when delivering cargoes to the town. From the eighteenth century the chief export was coal, destined mainly for America. Ships usually returned carrying new wooden pit props for the local mines. By the 1960s the port at Alloa was struggling to compete with the other ports further downstream and it finally closed in 1970. Prominent in the background are the buildings of the Alloa Glassworks.

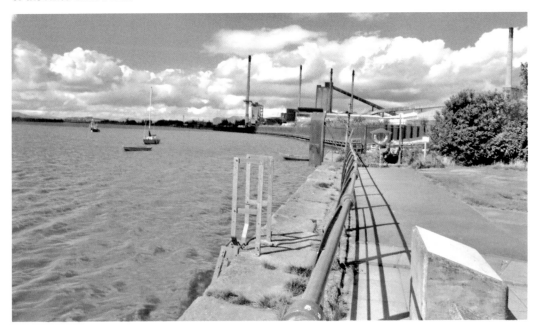

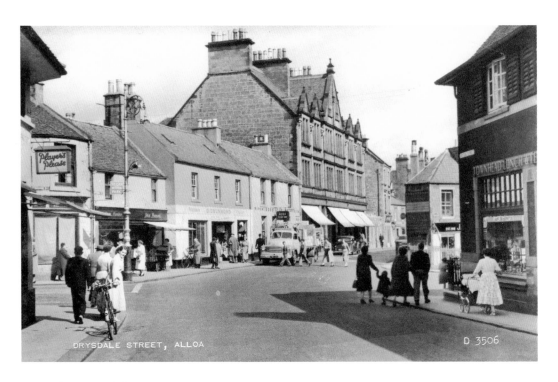

Alloa, Drysdale Street 1

Most of the buildings seen in this 1958 postcard view are still located at this vantage point today. The obvious exception is the building seen at the top of High Street on the corner. Many people will still remember a few of the shops on show, such as Mary Hunter and John Pearson, which may have been a grocers or confectioners shop, Drummond the Fruiterer and Florist and the Ross Star Inn.

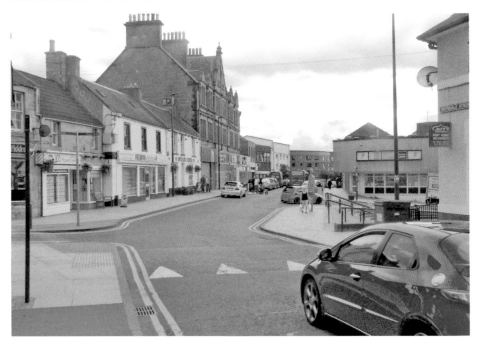

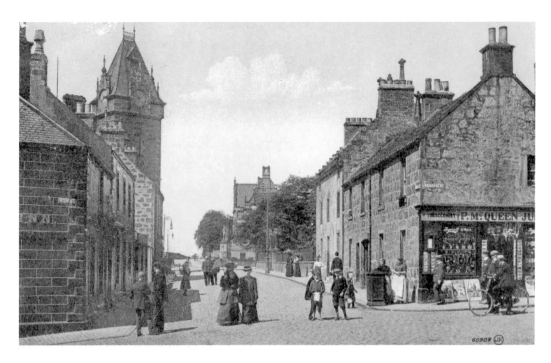

Alloa, Drysdale Street 2

We are now looking back up Drysdale Street from its junction with High Street and we have the Town Hall as the central focal point. The buildings in the immediate foreground have all been replaced in recent years. This location is also known locally as 'The Corner'. It was near the top of the road that the Boer War Memorial was situated. This memorial is now located near Ludgate, not far from the town centre.

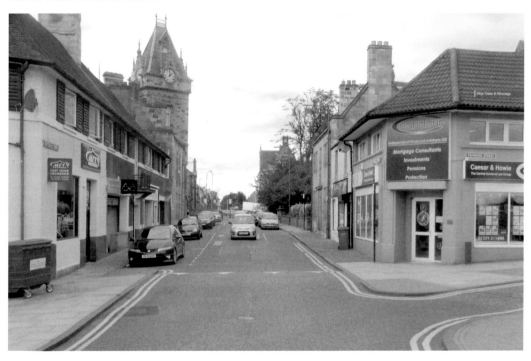

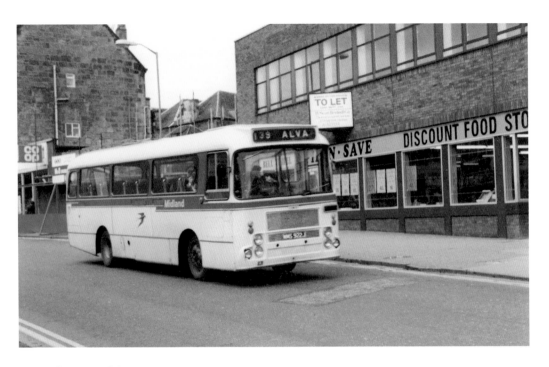

Alloa, Drysdale Street Bus

Monday 2 November 1981 was the day the buses started using the town centre instead of the Ring Road. This photograph shows WMS922J (MLH22), a Bristol LH with Alexander Y-type bodywork, travelling down the town's Drysdale Street on the local service 139 to Alva. The building on the right of the bus is now home to a dental practice while the Co-op to the rear is presently part of a discount store. The scaffolding poles seen behind the bus were at the location for the building of what is now a TSB bank.

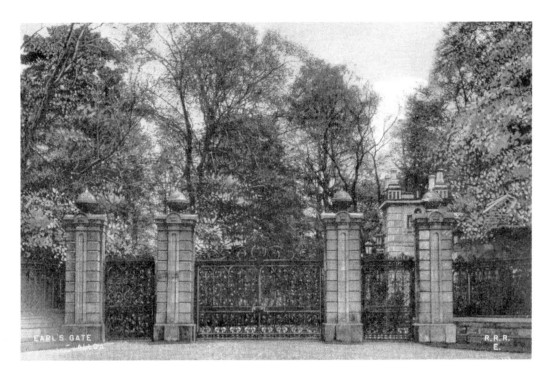

Alloa, Earl's Gate

What a complete shock it was to see such a magnificent and elegant entrance looking so meaningless and pointless. It just doesn't look right as it does not serve any purpose. In the old postcard image, you could see the point in having such a grand entrance, but because there is no park there anymore, the remaining pillars look lost. Such a shame!

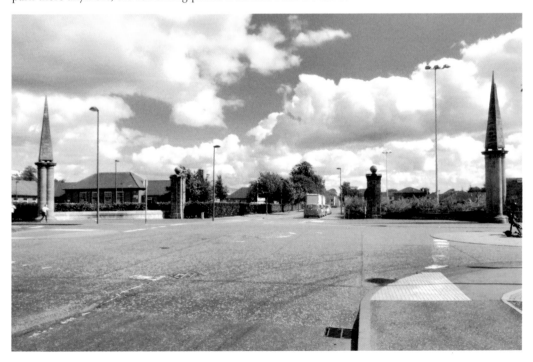

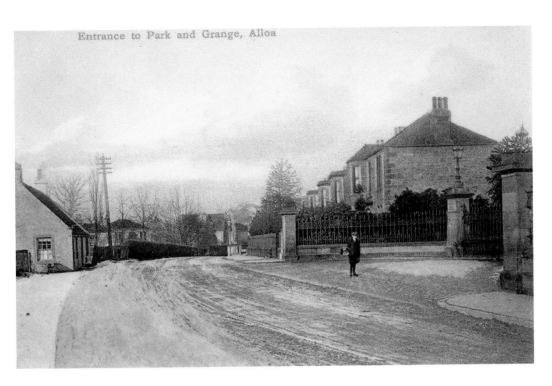

Alloa, Entrance to Park and Grange

Not much has changed at the entrance to the park on Grange Road. As you will notice in a lot of the images, the main difference is with the removal of railings. The ornate lamps have also disappeared from the top of the entrance columns but the houses are still all present behind the large tree. The only visible exception is with the removal of the cottage opposite the entrance to the park.

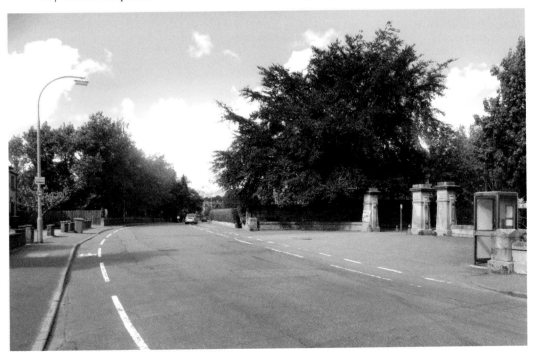

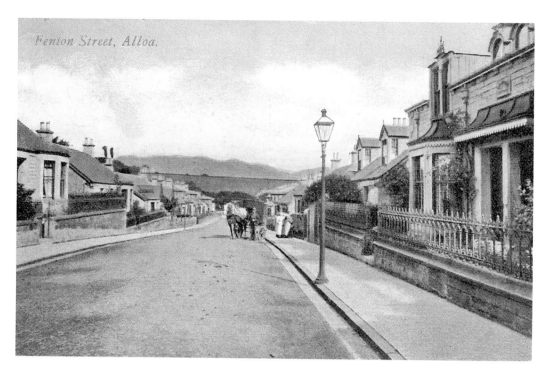

Fenton Street, Alloa.

Alloa, Fenton Street

It is always nice to see little change when comparing street scenes almost a century apart. There are a few more modern buildings to be seen in the distance in the present-day image. Other obvious differences include the change in lamp standards and vehicle types. No more horse drawn wagons to be seen, but plenty of cars can now be found parked along the street.

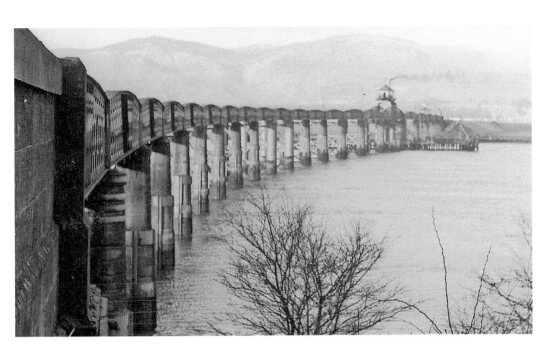

Alloa, Forth Bridge

Authorisation was granted to the Alloa Railway Company to build what was called 'the other Forth Bridge' in 1879. It was completed and opened in 1885, when the Alloa Railway was a part of the Caledonian Railway Company. This line crossed the River Forth from Throsk and reached the peninsula to the south of Alloa. The bridge had a central span which was steam driven and could be opened to allow shipping to pass. The line closed to passenger traffic in 1968 and to freight two years later. The spans were removed in 1971 and all that remain today are the piers. These views are taken from South Alloa, near Throsk, and are looking towards Alloa, which is off to the right of the images.

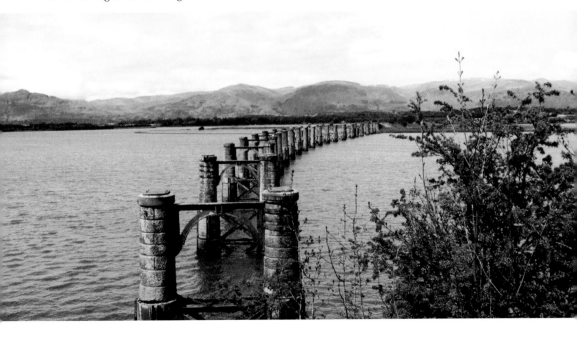

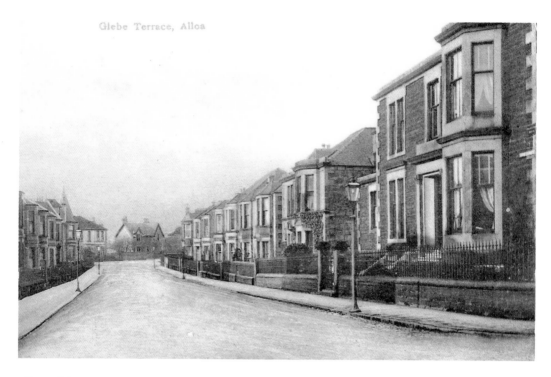

Alloa, Glebe Terrace 1

Another surprise was found when comparing these images looking down Glebe Terrace. These images are taken looking from east to west towards the junction with Ludgate with practically no changes to be found. The garden hedges have grown a little bit bigger, but this is in no way displeasing or indifferent.

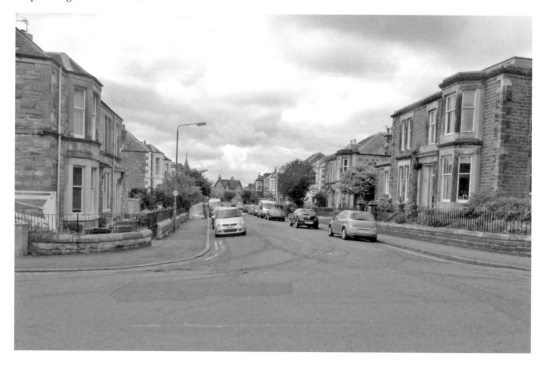

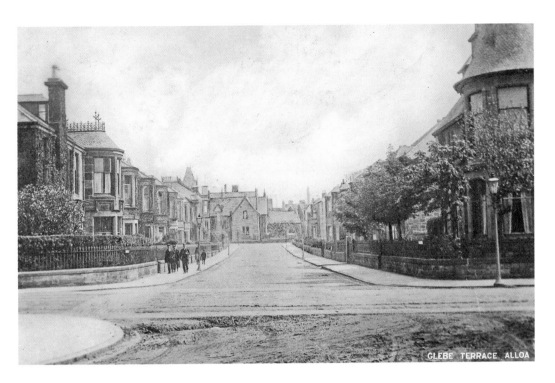

Alloa, Glebe Terrace 2

Glebe Terrace is again the subject matter, but we are now looking from west to east from the junction near Coningsby Place. This allows us to have a look at the conical roofed house at the west end of the street. Once again, there are practically no major changes to be found. I am glad to say that the road surface is a lot better now than it looks in the older postcard image.

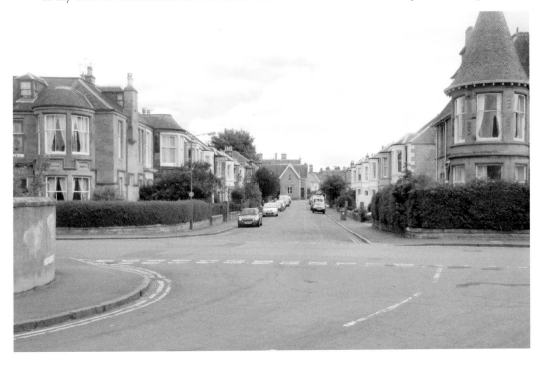

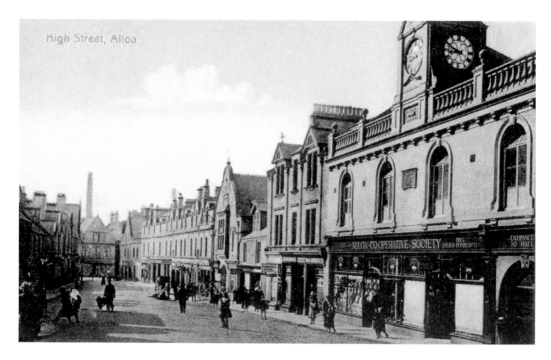

High Street, Alloa

Alloa, High Street 1

A view of the High Street looking down from the northern end, and we see a lot of familiar buildings. The main difference is to the location of the Corn Exchange, which later became the Central Picture House, which was located about half way down the street on the right hand side. A few of the buildings on the left hand side of the old postcard image have been replaced by more modern buildings while you might have noticed the modern 'statues' dotted around the area too.

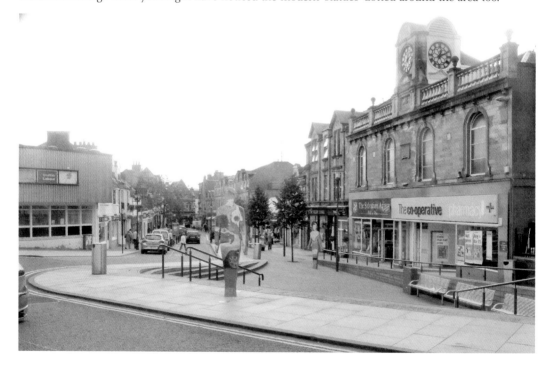

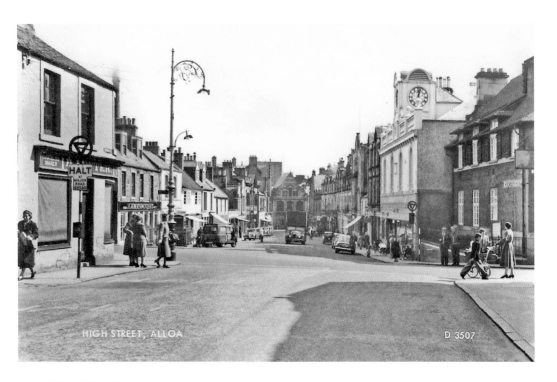

Alloa, High Street 2

Taken almost half a century after the previous old postcard image, here we see another view looking down the High Street, but photographed from just inside Primrose Street. Nothing much seems to have changed over the intervening years apart from the modern day transport. The old image is a good intermediate photograph as we compare it to the present day.

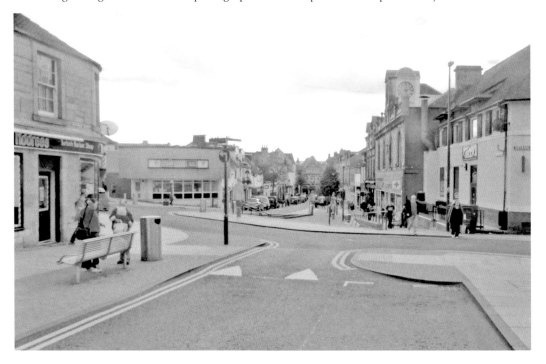

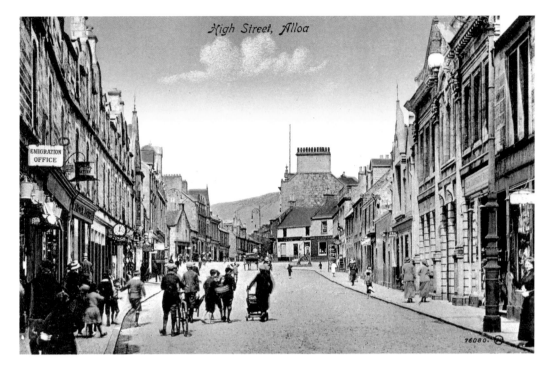

Alloa, High Street 3

We are still on the High Street, but looking northwards from near the junction with Mill Street. We can see little change at the top of the road where the junction between Drysdale Street and Primrose Street is situated. Among the shops in the old postcard image, we can see an Alloa Co-operative building, a tea room, a hatter, an ironmongers and an emigration office.

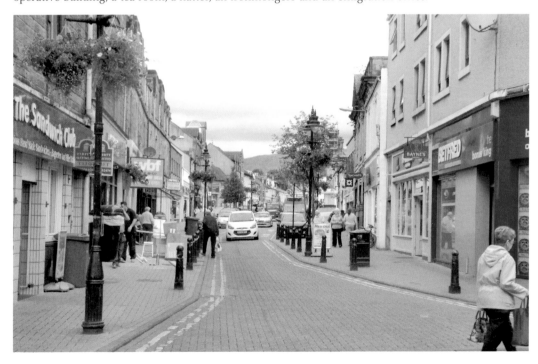

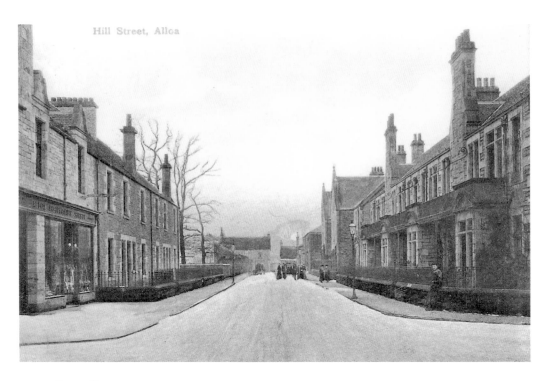

Alloa, Hill Street

A lot of change is evident when comparing the old postcard image with the one taken in the present day. The buildings on the left are still in use, although the old Alloa Co-operative Society store on the corner is now a similar type of shop, run by a different company. All other buildings in the old image have now been replaced by relatively new modern housing as seen in the present day image.

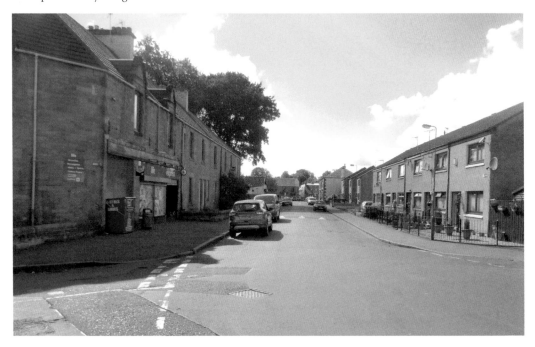

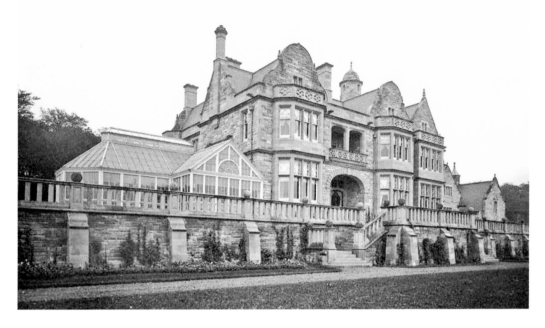

Alloa, Inglewood House

Situated just off the town's Tullibody Road, Inglewood House has remained largely unchanged from when it was built at the start of the twentieth century. Designed by Sydney Mitchell & Wilson, it was built for Alexander Forrester-Paton, the husband of one of the granddaughters of mill owner John Paton. It was latterly used as an Eventide (care) home for many years, but after restoration it is now being used as a business and conference centre.

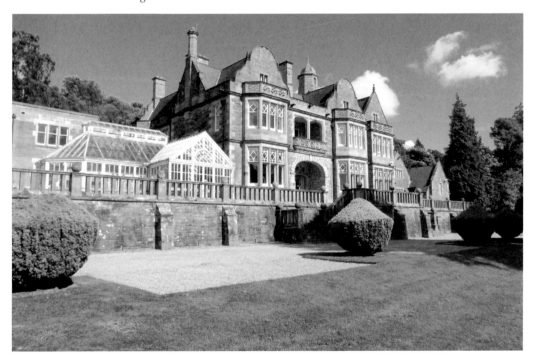

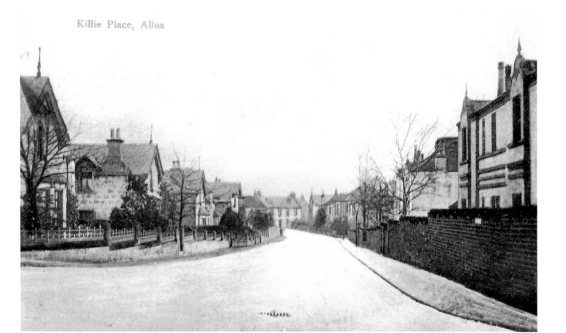

Killie Place, Alloa

Alloa, Kellie Place

Another street where the buildings seemed to have escaped any form of major alteration is Kellie Place, situated between Claremont and Mar Place to the north-west of the town centre. The road layout has been changed, however, the western end of the street becoming part of a one way system from Stirling Road to Marshill. Note the spelling of the street name on the postcard, a common fault on postcards dating from about the early 1900s.

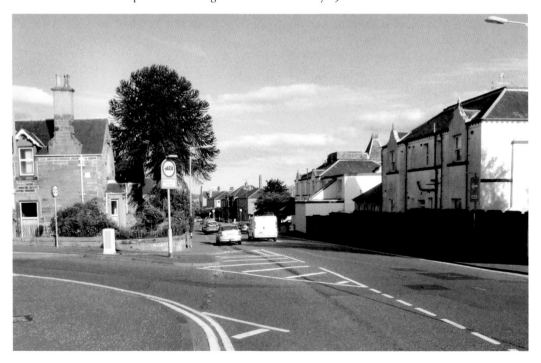

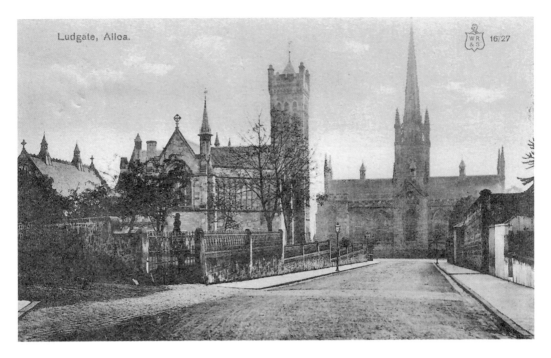

Alloa, Ludgate

Alloa is lucky to have so many places that have remained unchanged over the last century or so. The bottom of Ludgate is one such area as we look towards St Mungo's parish church on Bedford Street. The church on the left is Ludgate church, built in the early 1860s in an early French Gothic style. It was further enhanced in 1902, thanks to David Thomson and his brother, John Thomson Paton, who paid for the work to be done.

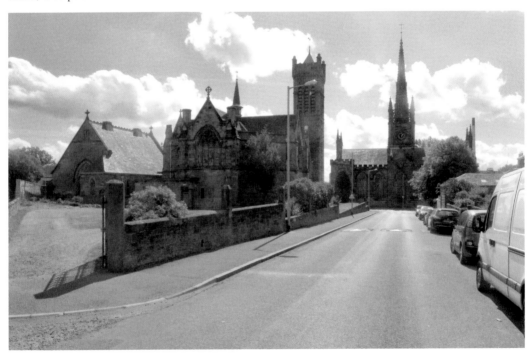

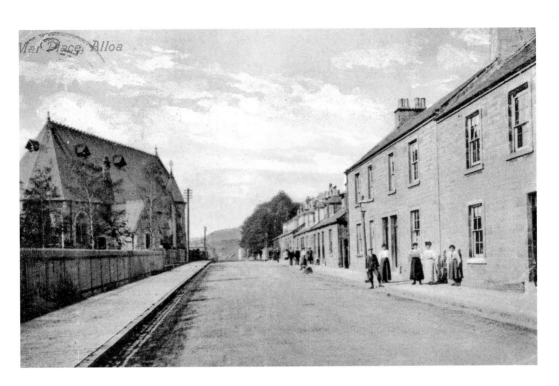

Alloa, Mar Place

Only Alloa parish church remains as the link between the two images shown here. All the housing on the right hand side of Mar Place, as we look towards Inglewood, has been knocked down and replaced by more modern housing, including Ludgate House opposite the church. Ludgate House provides day care and respite care services for the elderly in the area.

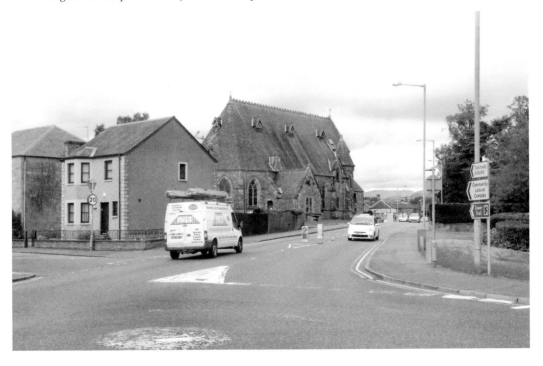

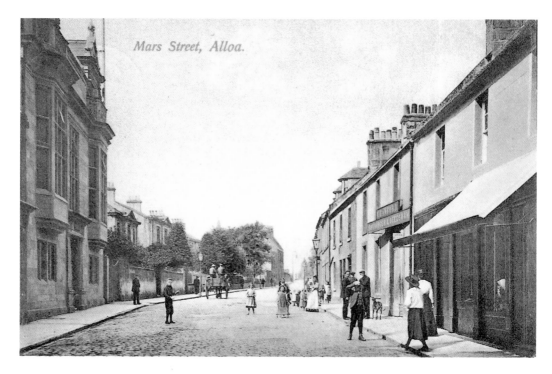

Mars Street, Alloa.

Alloa, Mar Street

The most notable change to have happened between these two images is at the far end of the street as we look north-westward from the junction at Candleriggs, Bank Street and Mill Street. The sign on the shop on the right of the postcard image is for 'Crawford', who was apparently a 'Greengrocer & Seedsman'. The same building today is home to the *Alloa & Hillfoots Wee County News*. Those with sharp eyes will have noted the spelling of the street name on the old postcard.

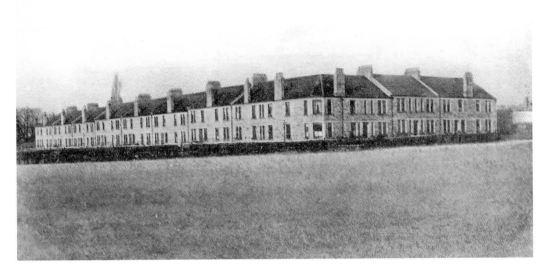

Alloa, Medwyn Place and Forbes Street

It is now impossible to take a modern day photograph from an equivalent position. The grassy area in front of the housing block at the junction of Medwyn Place and Forbes Street is now part of a vast housing estate that surrounds this area. What does stand out nowadays when comparing the two images is the absence of the chimney stacks, which seemed to stand proud and prominent in the old postcard image.

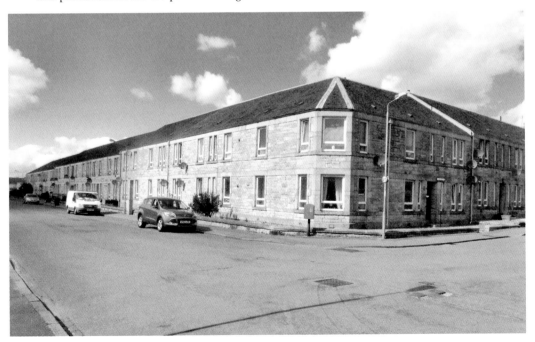

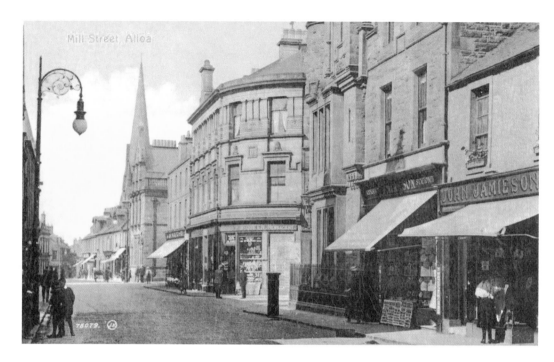

Alloa, Mill Street

These views, looking south-west down Mill Street, were taken from an approximate half-way location. The changes here are to the buildings on the right hand side of the images, just before the junction at the bottom of High Street. Most of the older buildings on this part of Mill Street were replaced when parts of the Town Centre were redeveloped in the final quarter of last century.

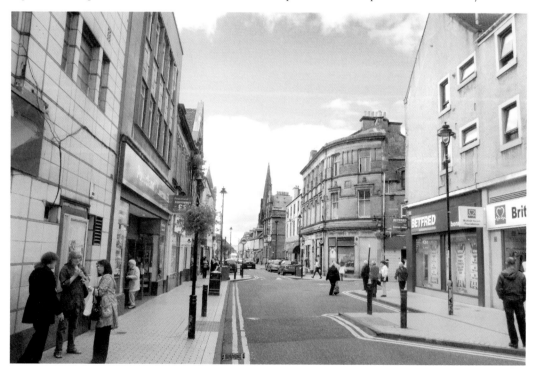

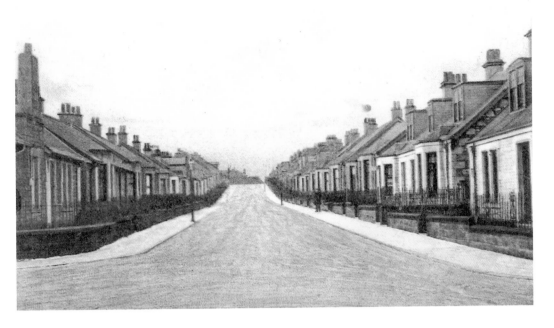

Alloa, Paton Street

Named after local mill owner John Paton, Paton Street is another one of the streets that show little or no change when comparing the old and new images. As a residential street, it does get busy with cars, especially in the evenings, and makes a stark contrast to the old postcard image from the early 1900s.

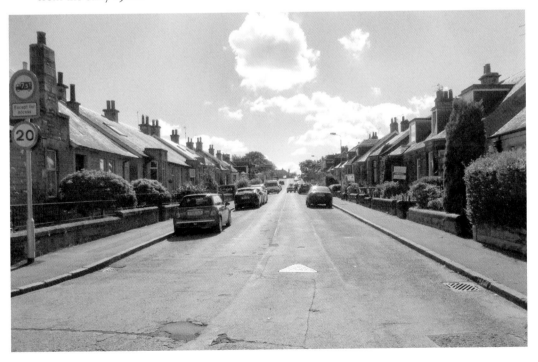

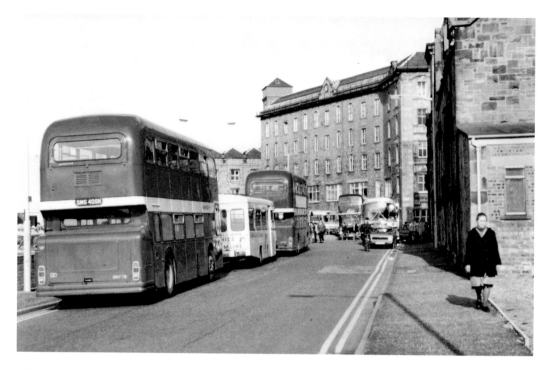

Alloa, Patons & Baldwins Buses

The older image indicates how busy the mill was by the number of buses that were used to take workers to and from the mill in the morning and the late afternoon. It was a sad loss to the town as it had employed many generations of members from many families around the area. The site is now in use as a car park and Tesco superstore.

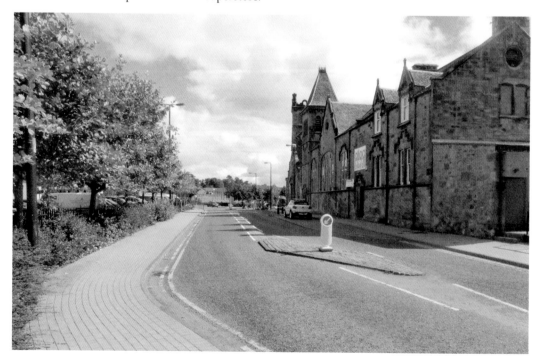

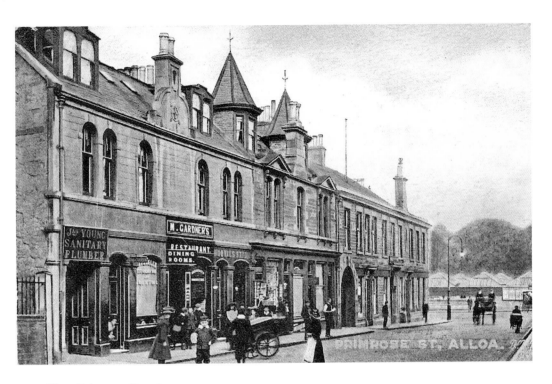

Alloa, Primrose Street

A mixture of housing and retail is evident in both images with not much having changed about the building. Two chimney stacks have been removed and the building frontage has been (mostly) painted a variety of shades of cream. The pyramid shapes on the right of the old postcard image are the canopy roofs covering the platforms of the railway station below.

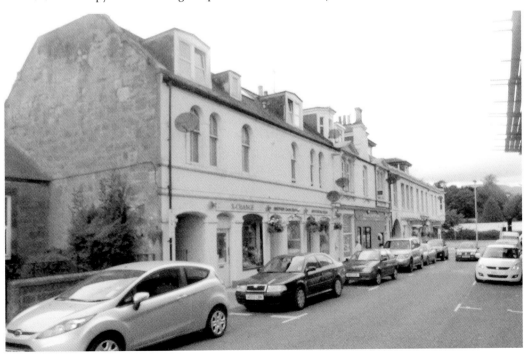

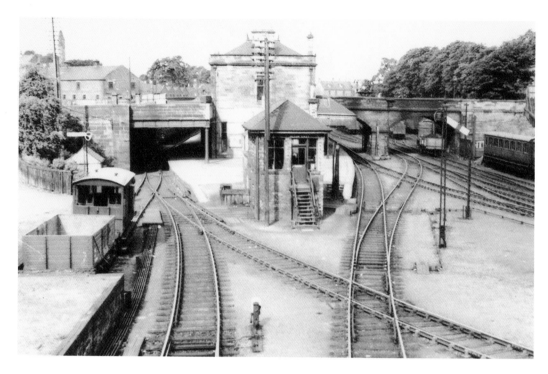

Alloa, Railway Station

Alloa had quite an extensive rail layout for a small town. It was well served by trains to and from Larbert, Stirling/Glasgow, Dollar/Kinross/Perth and Dunfermline. This is the east end of the station, showing the lines below the photographer heading to and from Dunfermline. The lines curving off to the right were the lines serving Dollar and onwards to Kinross and Perth.

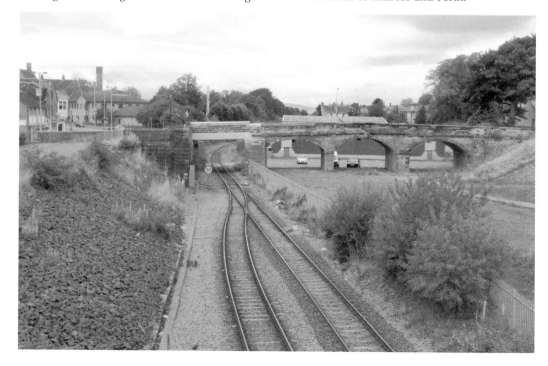

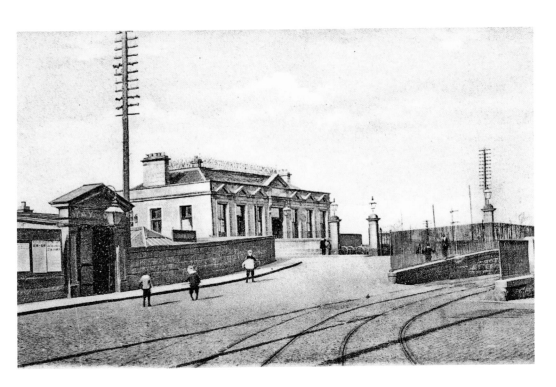

Alloa, Railway Station Frontage

Built by the Stirling & Dunfermline Railway and opened for passenger services from Dunfermline in 1850, the line from here was eventually opened for passengers from Stirling two years later. An attractive station with the entrance located above platform level from the overhead bridge. The old station closed for passenger use when the line was axed by the infamous Dr Beeching in 1968. Alloa was finally reconnected to the rail network in 2008 after much local pressure.

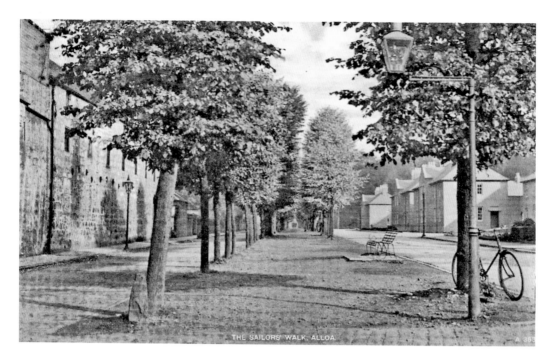

THE SAILORS' WALK, ALLOA

Alloa, Sailors Walk

When heading from the town centre towards the harbour and dock area, the merchant seamen, and tradesmen, would have travelled down Broad Street and Lime Tree Walk nearer the harbour. It was because of the continual usage by the sailors that the lime tree lined walkway earned the nickname of 'The Sailors Walk'. Sadly, these trees were pulled down in 2008 and the area looks totally different to the view of the old picture postcard.

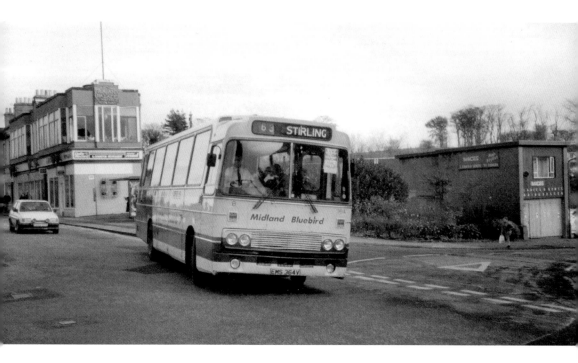

Alloa, Shillinghill

The view of the buildings on the left hand side when comparing images shows little or no difference between the two. There is a major difference on the right, however, as the area was redeveloped following the closure of the Maclays brewery in 1999. The bus, EMS364V, was a Leyland Leopard with an Alexander T-type of body. It was allocated to Bannockburn depot and carries the fleet number 364 and is seen here on a local service 63 to Stirling.

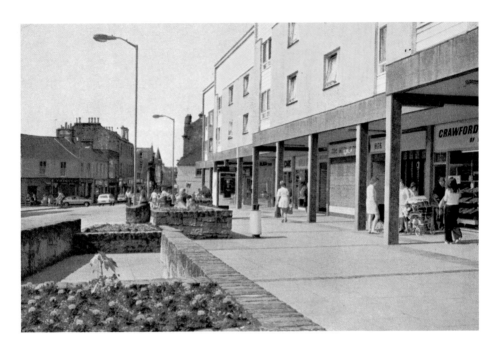

Alloa, Shillinghill Maple Court

This complex was built in 1970 when the area was undergoing extensive redevelopment. Although it is a relatively new development, it has undergone a couple of further refurbishments which have tidied up the look of the building. The properties have received external painting every five years since 1983. All bus services through Alloa now stop at three stances which sit adjacent to the retail outlets, which also mean the walled flower beds were also removed during one of the refurbishments. The former Maclays brewery previously mentioned was situated behind, and to the left of the Thistle Bar seen on the left of the old image.

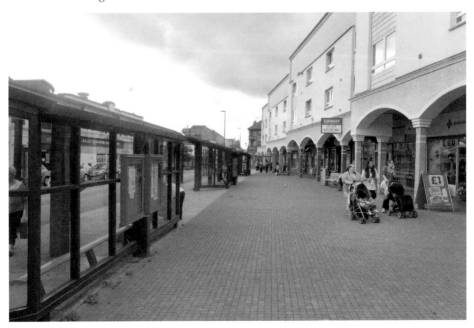

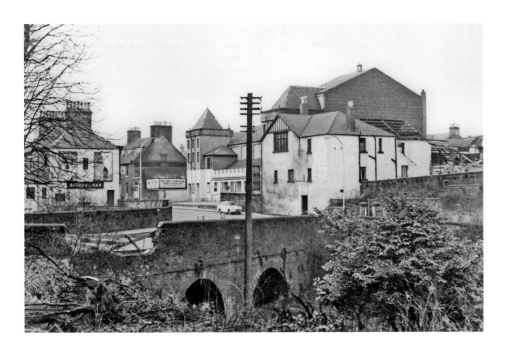

Alloa, Shillinghill Northern End

It is hard to believe that the northern end of Shillinghill looked like this. Nothing seen in the old black and white image remains today. The prominent features were the old Pavilion Cinema in the centre of the image, and the bridge, which seems to have had some vehicular damage to the bridge wall. Also seen on the left is the 'Bridge Bar', while on the right it can be noticed that there is some demolition work going on, possibly due to redevelopment in about 1970. Standing prominently on Shillinghill roundabout in the present day photograph is the statue called *Lifeline*, by internationally renowned artist Andy Scott.

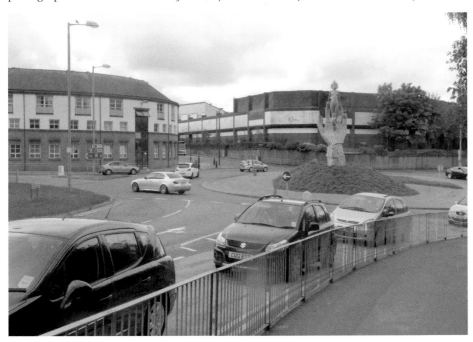

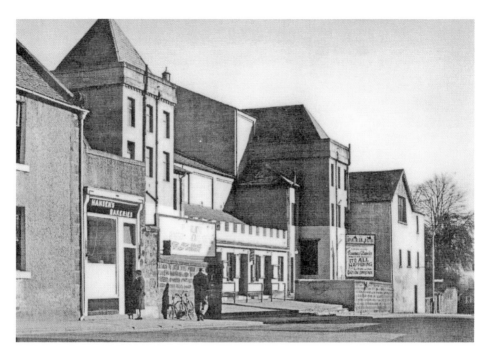

Alloa, Shillinghill Pavilion Cinema

Another one of Alloa's three cinemas was the much loved Pavilion, found near the northern end of Shillinghill. This cinema, which opened in 1913 by Alloa Picture Palace Ltd, had seating for 966 patrons. It was sold to Fife Entertainments in 1949 but eventually closed about 1964. It was demolished around the 1970s and a supermarket was built on the site later on. The location is still used by various retail units today.

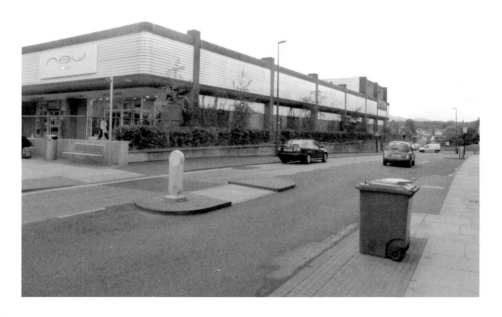

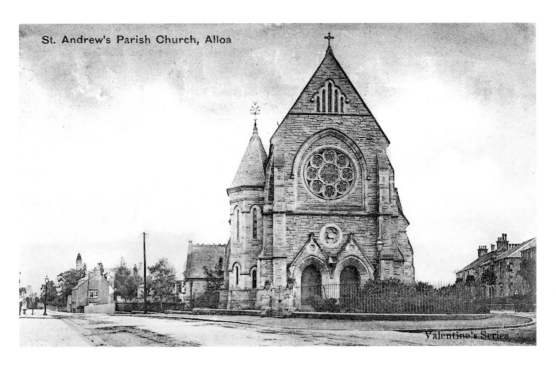

St. Andrew's Parish Church, Alloa

Valentine's Series

Alloa, St Andrews Parish Church

Designed by Peddie & Kinnear, this church was built on the site of the Ludgate, or round toll, in the early 1880s and is described as having a 'massive' appearance with buttresses and deep splays on the window jams. Through a succession of amalgamations since its inception, the St Andrews parish church eventually ended up as the North Parish Church. It is an awesome looking structure and is quite imposing when entering the town centre from Tullibody to the north-west.

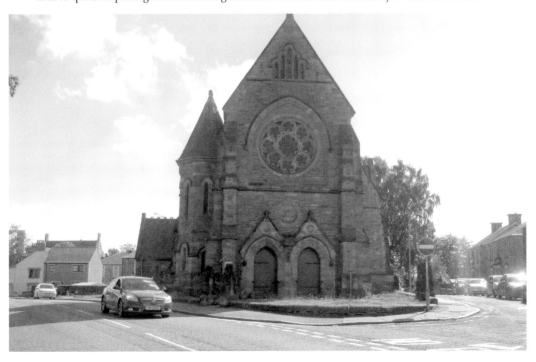

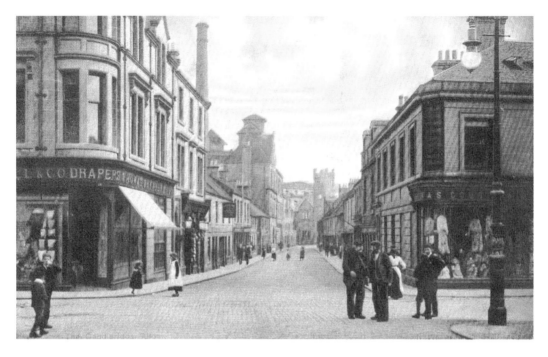

Alloa, The Candleriggs 1

Taking a look down Candleriggs after a century, the building on the left corner, on the junction with Mill Street, is still very much in use although no longer trading as a draper's shop, while the shop on the right is now a Semi-Chem, but in the old image, it is seen to be in use as a ladies outfitter. This old image must predate the old image of 'The Cross' shown later in the book as the ladies outfitters doesn't have the lamps on the shop frontage.

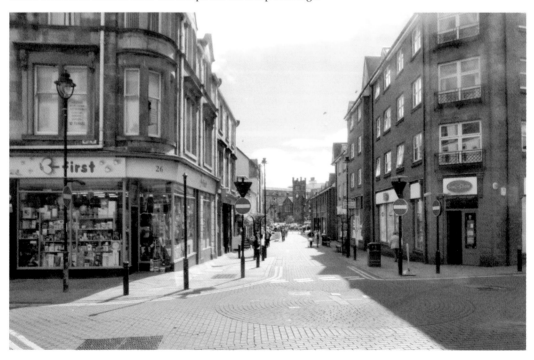

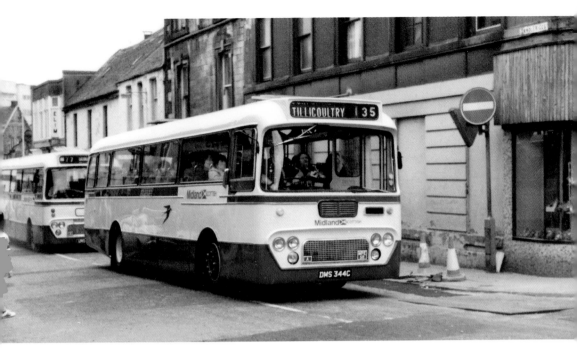

Alloa, The Candleriggs 2

I included this image of Candleriggs as it is one that shows the stark contrast in the buildings on that particular side of the street. My opinion is that the red brickwork of the new building looks out of place and doesn't fit in with the surrounding buildings. The sight of the workers' buses heading to the outlying towns and villages will stir a few memories too, especially if you used these bus services yourself. At 'lousing time', a policeman used to be stationed on points duty at the Cross to help traffic in the area. The Patons Mill had a huge catchment area.

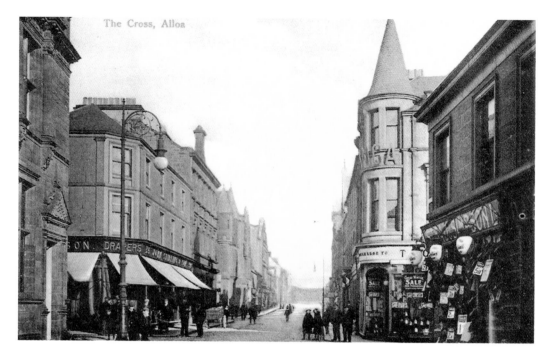

Alloa, The Cross

This view is taken from just inside the start of Bank Street, and shows us looking north-eastward. Only the building on the right, which is actually just inside Bank Street, has been changed. On the near right hand corner is Stead & Simpson Ltd, which has three lamps above the frontage of the shop. On the far right corner, a YMCA stands over a ladies outfitter, which is seen displaying posters for furs and corsets. Across the road, on the far left, can be seen the premises of John Stirling & Son, Drapers.

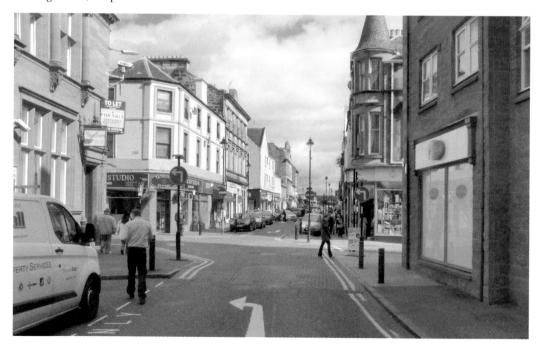

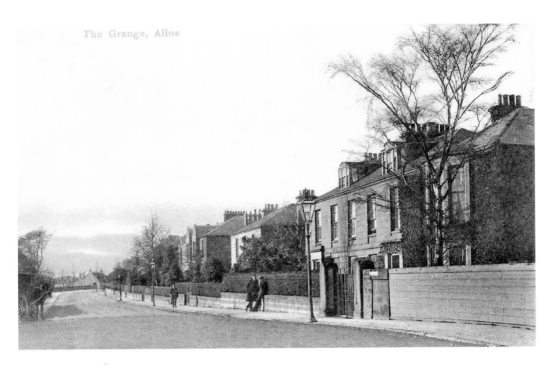

Alloa, The Grange

The Grange, or Grange Road as it is today, is one of those places that seem to crop up quite often in Alloa where you have a mixture of old buildings and relatively new ones on adjacent sides of the street. It is always good to see the architects at least trying to blend the newly built homes in with the ones built perhaps a century earlier. They have tried to incorporate bay style windows and conical roof styles along with other ideas. Perhaps a little bit of greenery is all that is required to balance the two sides of the street off.

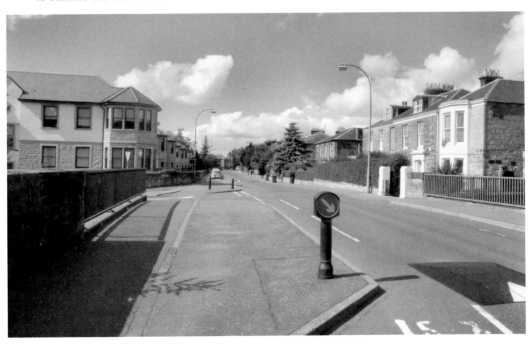

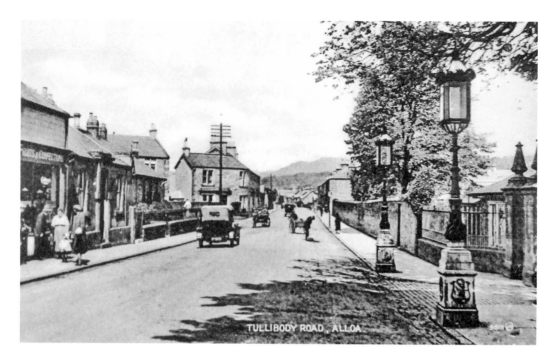

Alloa, Tullibody Road 1

Looking towards Tullibody, the lamps on the right hand side of the old postcard image are situated at the entrance to Greenfield Park, which up until 1952 belonged to the Paton family and were the private grounds in which Greenfield House is situated. Now under control of Clackmannanshire Council, the entrance has changed dramatically. The rest of the buildings near the junction with Ochil Street and beyond, including the large tree in the park grounds, seem to have escaped any change.

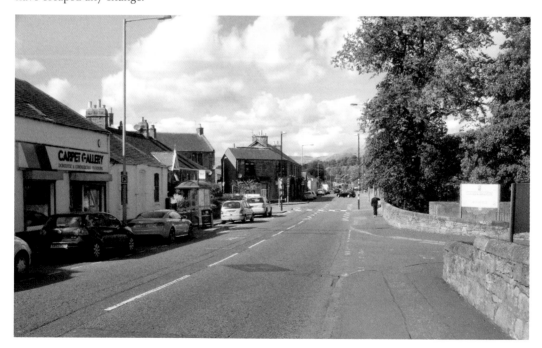

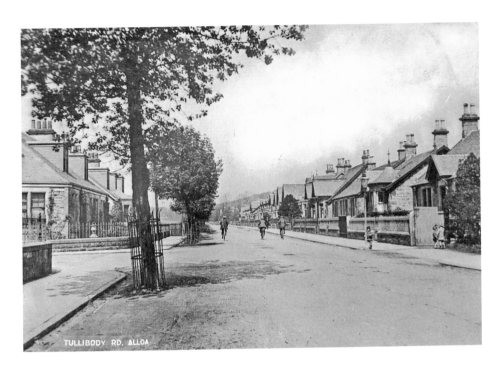

Alloa, Tullibody Road 2

Surprisingly little has changed at this location further down Tullibody Road, still looking towards Tullibody. This is at the junction with Paton Street, seen exiting left in the old postcard view. It is my belief that the trees seen just at the roads edge are the same trees still there at present. Only the width of the road seems narrower nowadays, with the left hand pavement extended to accommodate the trees.

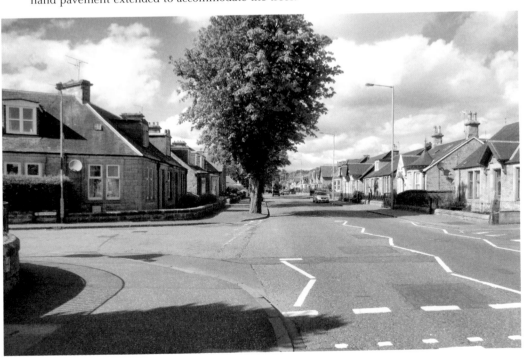

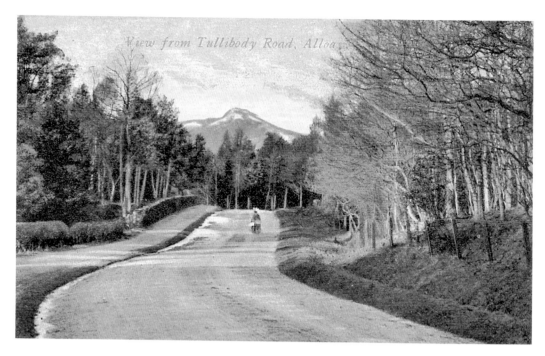

Alloa, View From Tullibody Road

This must be the extreme north-west limit to Alloa as we look towards the Delph at the eastern edge of Tullibody. This location is just past the present Lornshill Academy School on Tullibody Road, and we are looking at the stretch of road where its name changes to Alloa Road. This area is still wooded on both sides of the road, but the housing within Tullibody has extended far enough eastward to be seen now at the top of the hill.

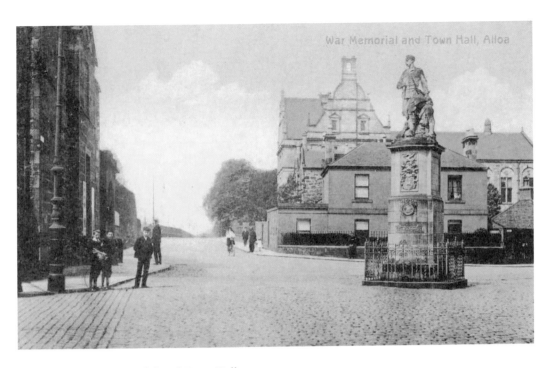

Alloa, War Memorial and Town Hall

The old picture postcard image shows us at the present day junction at the top of Drysdale Street and Mar Street. This shows us the old location for the memorial statue dedicated to the men who died during the Boer War. This war memorial was moved to its present location on the north side of the junction between Ludgate and Claremont. It was basically for safety reasons more than anything else, as it sat in the middle of a road junction that was getting busier every year.

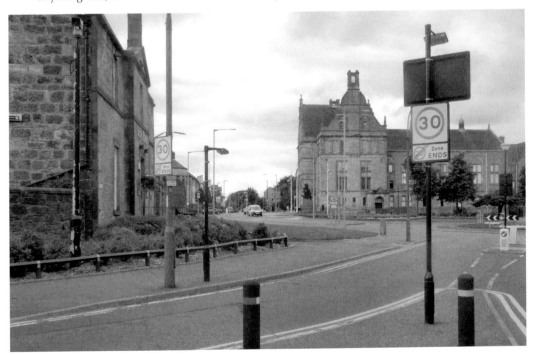

No. 124. Beauclerc Street, ALVA.

Alva, Beauclerc Street

I had to look two or three times to make sure I was in the correct location for this one. The old picture postcard is looking westward, along Beauclerc Street from the junction at Ochil Road and Brook Street. The two little girls are standing just in front of the small bridge that crosses over Alva Burn. The small cottage on the left has been demolished, as have the blocks of houses on the right just after the burn.

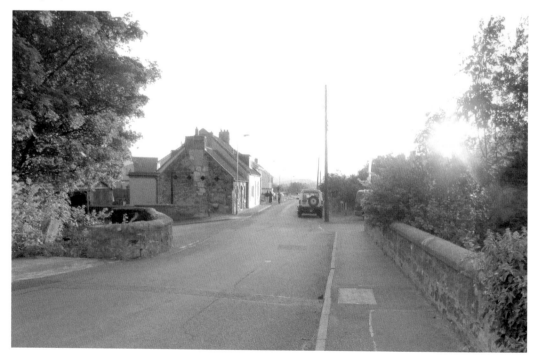

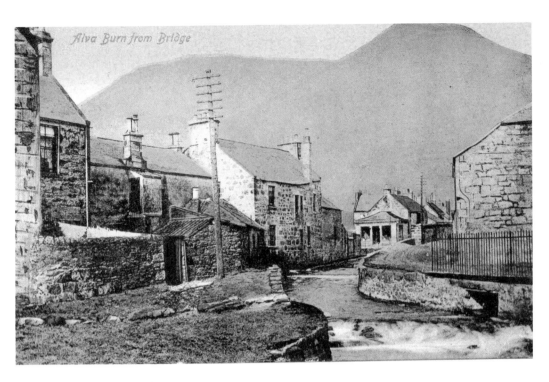

Alva Burn From Bridge

Although a lot of change has taken place in the area surrounding the burn viewed from Stirling Street, the area is still recognisable today. Many of the buildings in the background have had some cosmetic work carried out, and many have been replaced by more modern housing.

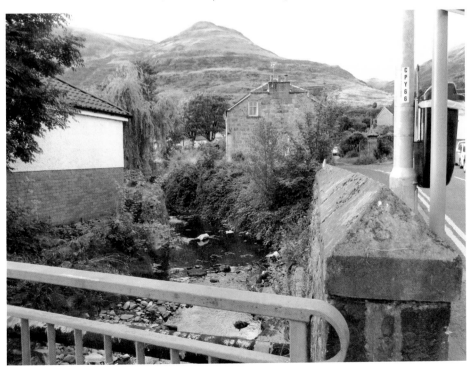

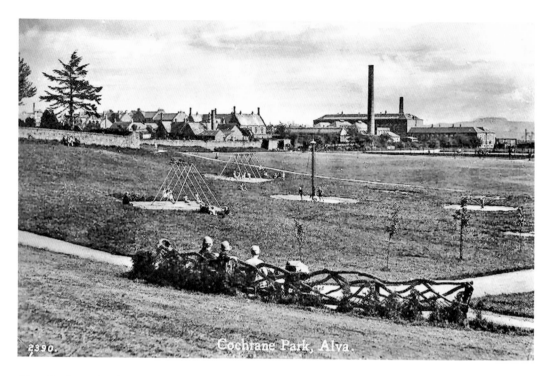

Alva, Cochrane Park

Although taken at the same location about eighty years apart, they seem to be quite contrasting views. Dominating the skyline in the distance of the old photograph is Glentana Mill, now a visitor centre for the Hillfoots Mill Trail. Today, the park has matured and the trees, seen as newly planted in the old postcard image, are now more fully grown and rather lush looking.

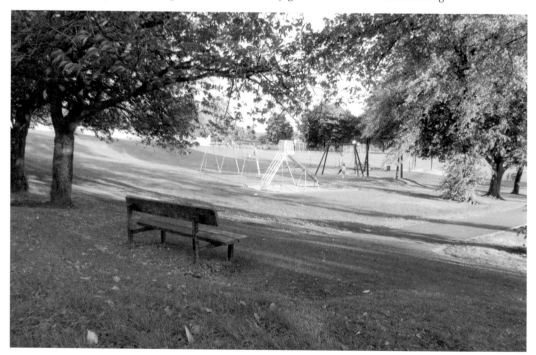

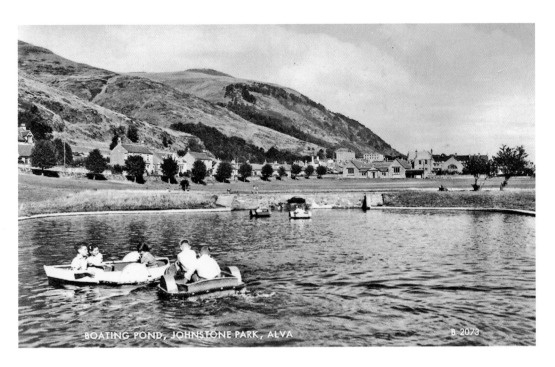

BOATING POND, JOHNSTONE PARK, ALVA

B 2073

Alva, Johnstone Park

Lying just off the north side of West Stirling Street, you will find Johnstone Park. This park was donated in 1856 by James Johnstone when he held the office as Member of Parliament for Clackmannanshire and Kinross. The park had a boating pond at one time, but this has now been filled in and is now a sand and water play area for children. The park is also home to the successful annual Alva Highland Games.

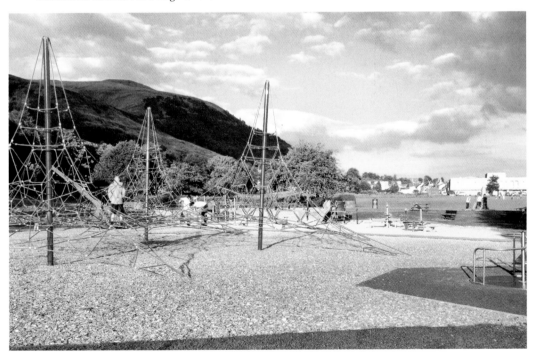

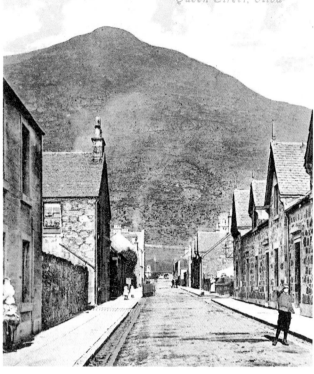

Queen Street, Alva

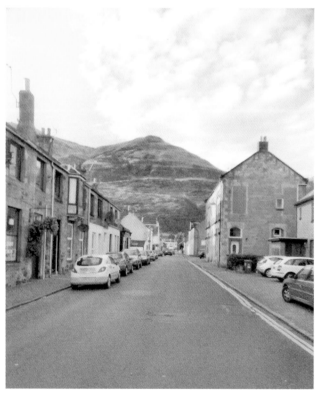

Alva, Queen Street

Looking up towards the north end of Queen Street, we see that much has happened to change the various housing and other buildings in the area. Only one of the rows of housing, seen on the right hand side of the street, remains while all other buildings in the old postcard image have succumbed to the developers' demands.

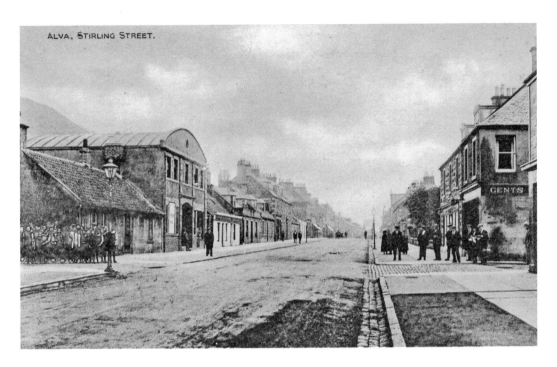

Alva, Stirling Street 1

This view, looking eastward along Stirling Street at the junction with Queen Street, seems to have escaped from too much development over the last century. The buildings on the right of the old image were retail units, including what seems like a gents outfitters. Today, this building is in use as a branch of the RBS. The large building on the left was the former Hillfoot Picture House and has been re-roofed at some point in its life. All other buildings on this side of the road appear to be the same original ones seen in the old image too.

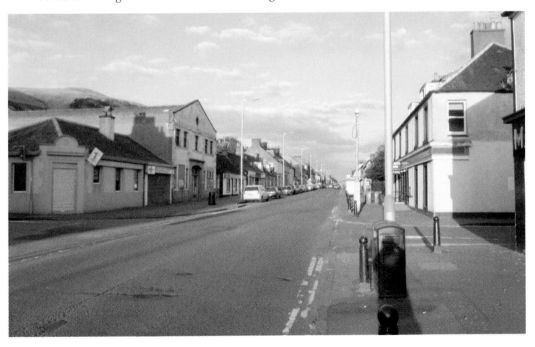

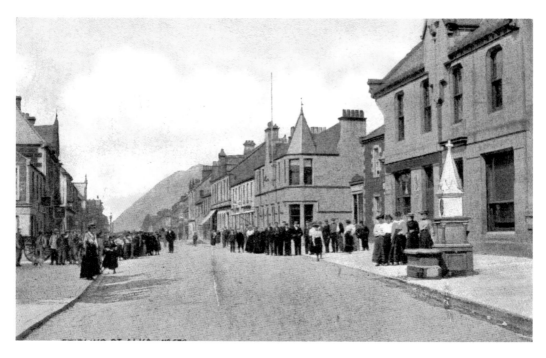

Alva, Stirling Street 2

Yet another view of Stirling Street, but this time we are looking to the west, just ahead of the junction with Brook Street. This was another delightful location that has also managed to evade any major change. There is a slight change to the road outside the building on the right which appears to have had what looks like a fountain outside it. This has been removed and a parking bay is now in the location of the fountain.

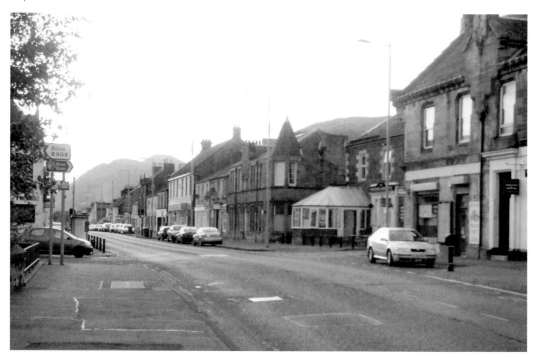

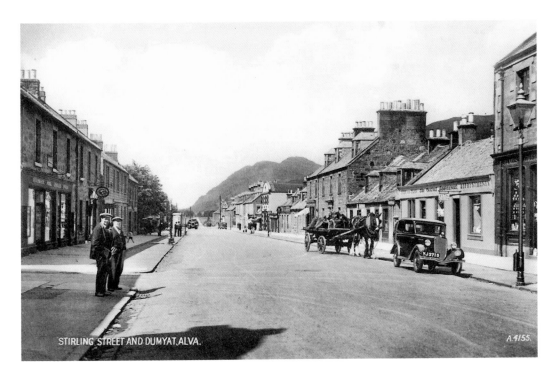

STIRLING STREET AND DUMYAT, ALVA.

A.4155.

Alva, Stirling Street and Dumyat

Further westward down Stirling Street, we come again to the area which was shown earlier. This image shows the curved original roof of the Hillfoot Picture House on the right hand side of the street in the old postcard image. The changes shown here include the new shops and houses on the right hand side of the present day photograph.

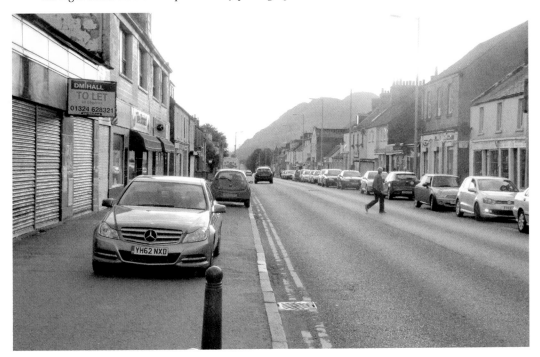

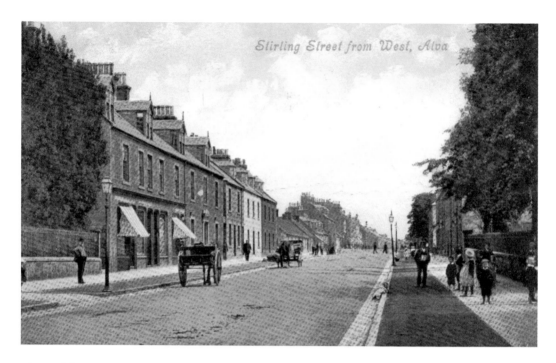

Stirling Street from West, Alva

Alva, Stirling Street From West

The last of our views of Stirling Street and once again we are looking from west to east. We find that the buildings on the left are still standing proud today, but the furthest away block has had some modification work carried out to the front layout. The centre area of the old postcard shows the location of the yet to be built Hillfoot Picture House. The large tree on the left of the old image has been removed and the area is now used as a car parking area for a bank.

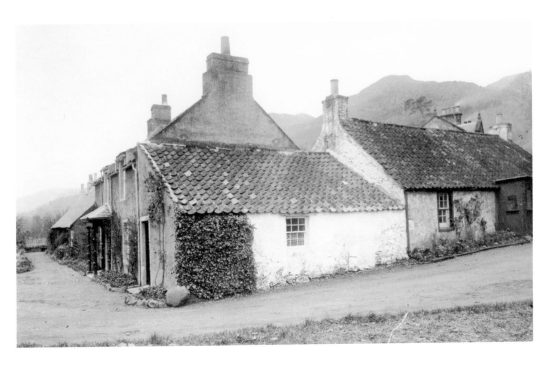

Blairlogie 1

It is always a pleasant surprise to find these types of buildings hidden away in 'the back streets', even more so when they look as charming as these ones. On the south facing house, we can see an added front porch and an extension to the building in the same style. The little cottage on the right also retains its charm, but has lost its front porch which, given its close proximity to the road, makes sense for safety reasons.

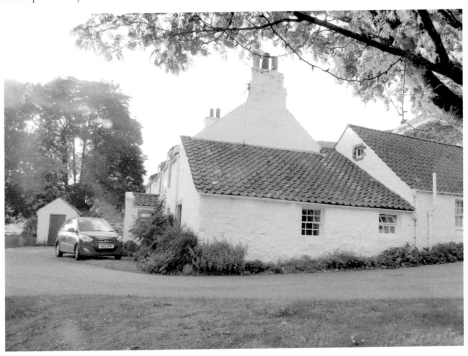

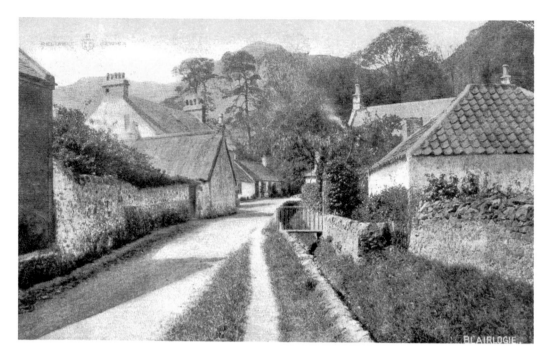

Blairlogie 2

Just a few yards up from the previous set of images, we find that our next location is easily identifiable. Certain buildings have had extensions added on to them, while the building on the right of the postcard image has been demolished. The wall on the left is now covered in ivy and the general area looks much tidier nowadays. On the right by the side of the road, a small walkway bridge can be seen crossing the small burn that runs adjacent to the road at this location.

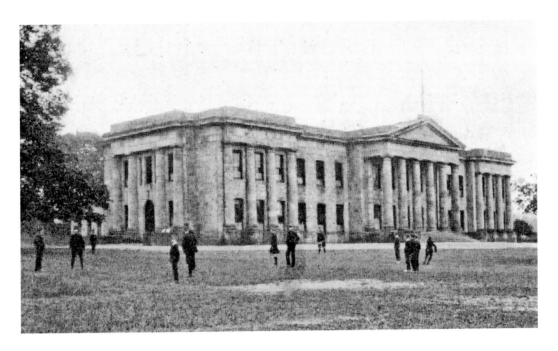

Dollar Academy

The Academy was founded in 1818 after a local wealthy merchant, John McNab, bequeathed £65,000 to provide 'a charity or school for the poor of the parish of Dollar where I was born'. McNabb died in 1802 but it took another sixteen years before the school opened its doors after much debate about how to use the bequest. It was in 1815 that the Revd Andrew Mylne, Minister of Dollar, along with his fellow Trustees conceived of a great academy to educate the boys and girls of the parish, and also pupils from outside Dollar, who would board with teachers. The school has remained unchanged over the intervening years between the two images.

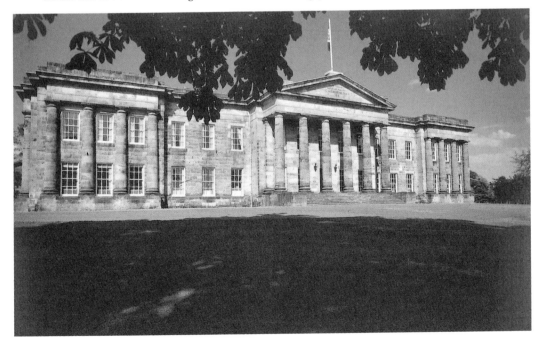

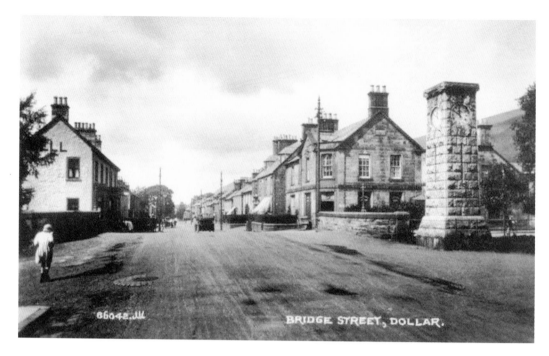

BRIDGE STREET, DOLLAR.

Dollar, Bridge Street 1

When we look westward from the bridge over the Kelly Burn in the old postcard image, the main difference seems to be in the removal of the telephone poles. My first thought was that they were street lamps, but no lamps of any type can be seen. All the original buildings seem to be all present and correct, with even the clock tower looking untouched. It seems as though time has stood still when comparing the two images. It is up to you to decide if the pun was intentional or not!

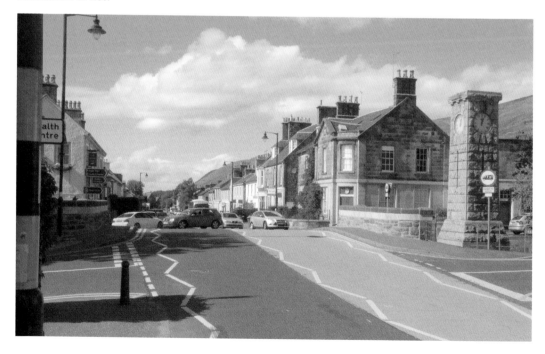

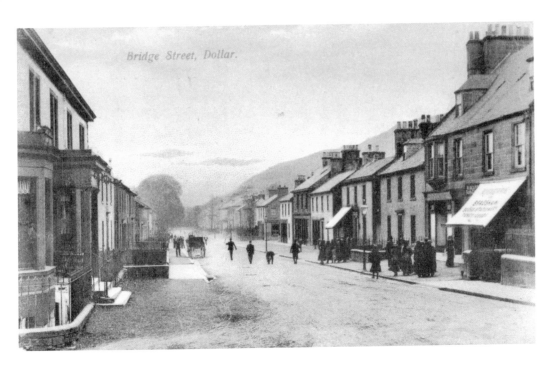

Bridge Street, Dollar.

Dollar, Bridge Street 2

Still looking to the west, but from a location just over the Kelly Burn Bridge, we find that the street now has lighting but the large telephone type poles are now removed. As previously mentioned, all buildings seem to be original, with only minor alterations having taken place. The awning on the shop on the right of the old postcard proudly displays the name of Bradshaw, who apparently sold books, stationery and fancy goods.

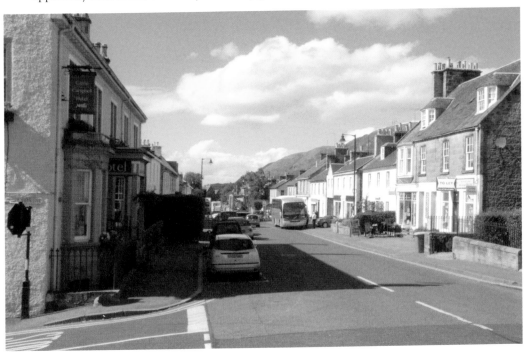

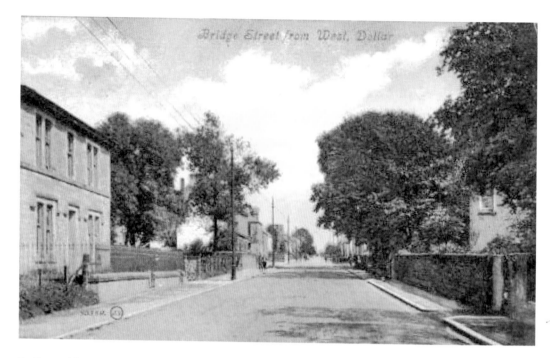

Dollar, Bridge Street From West

Most of what you see in the old image looking along Bridge Street from the west is still there, and still looks as original as ever. The only exception is the building on the left hand side of the image, which has been demolished and replaced by much more recent properties. This is on the junction with Mitchell Court, a relatively new development with a mixture of different property styles. A similar building to the demolished one is still in situ on the adjacent corner at the junction entrance.

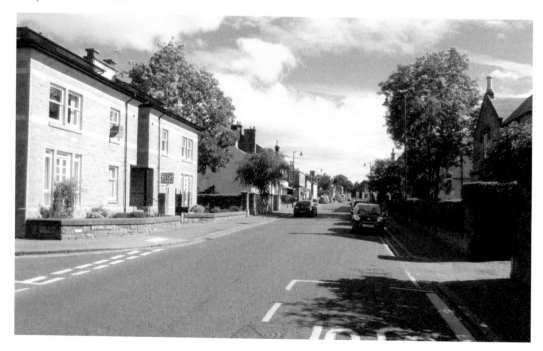

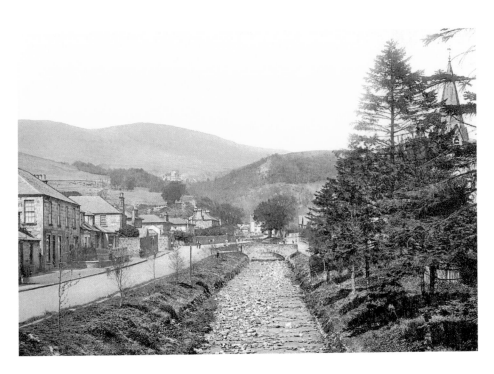

Dollar, Burnside

Nowadays, and depending on what season it is, it can be very hard to try and replicate certain views of old postcard images. This location is one of these situations, but it isn't so bad because there have been practically no major changes in evidence. The only difference is that the trees on the riverbank on the left hand side have grown a little bit more substantially. The spire at the East Burnside Hall of Dollar parish church can be seen at the top right hand corner of the old image.

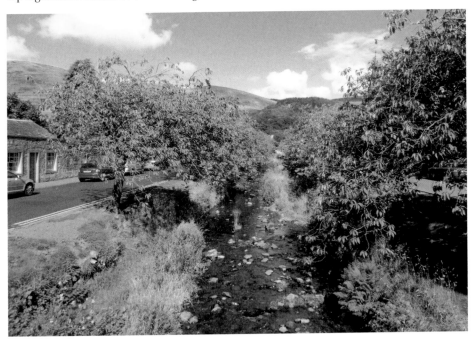

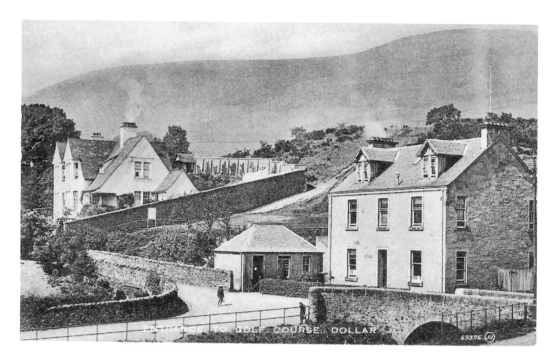

Dollar, Entrance to Golf Course

This delightful golf course can be found on Back Road, near the top of the junction with West Burnside. The course was designed in 1907 by Ben Sayers and was built without any bunkers as it was said that the natural contours and small plateau greens cut out of the hillside were difficult enough. The course is shared by both the ladies' and gentlemen's golf clubs. The ladies' club is wholly independent from the gentlemen's club. Surprisingly little has changed over the intervening years apart from the growth of trees and other types of foliage.

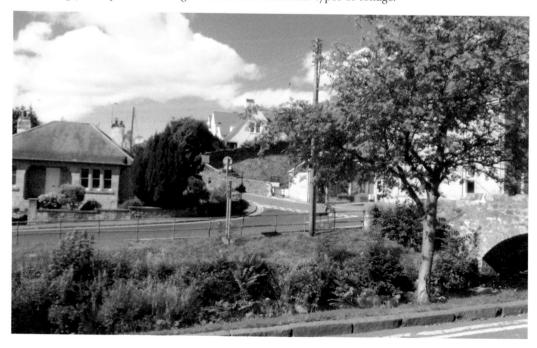

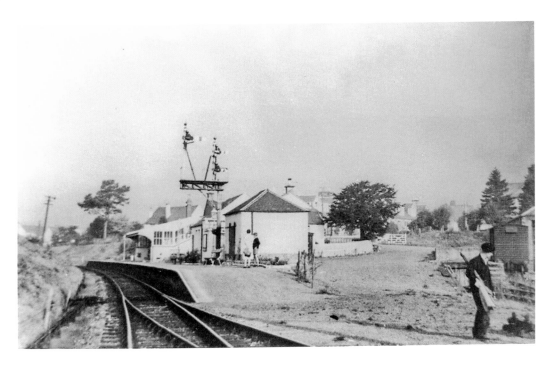

Dollar Railway Station

Dollar Railway Station sat on the Alloa–Kinross junction line and was known as the Devon Valley Line. The entire line closed to passenger traffic in June 1964, but the section from Alloa to Dollar remained in use to allow coal trains access to and from Dollar Mine. This remaining section also closed in June 1973 when the mine closed. The former station platform is still in situ with the track bed now a part of a walking and cycling track known as the Devon Way.

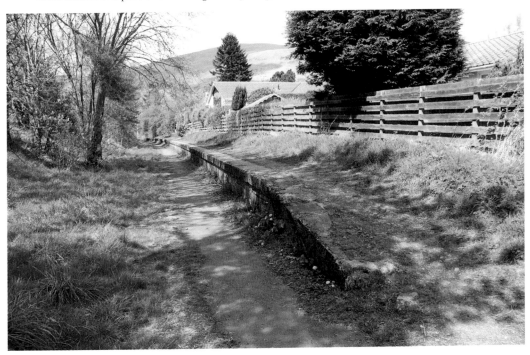

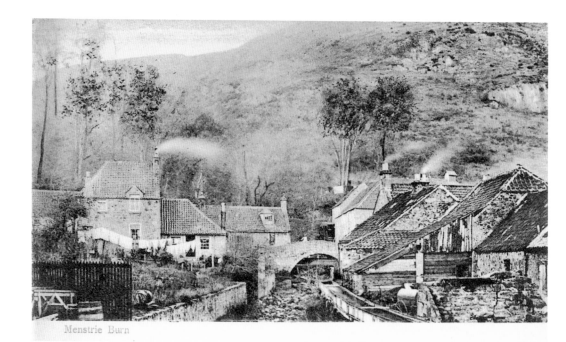

Menstrie Burn

Menstrie Burn

Some people would look at the old postcard image and think of utter decay, clutter and mess. My opinion is that the photograph epitomises everything that I imagine about the turn of last century. On the right hand side of the burn in the old image, we see what appears to be a water course. This may be the source of power for the carding and spinning mill which was set up on the east side of the Menstrie Burn to use its soft water and power. It is unfortunate that the present day view does not replicate the atmosphere generated in the old image.

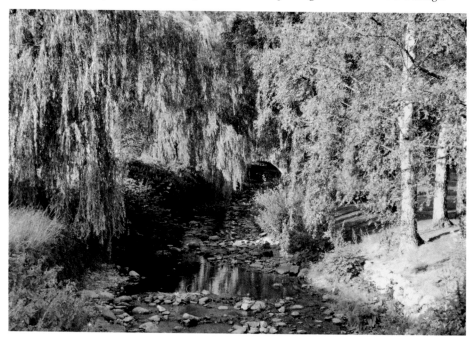

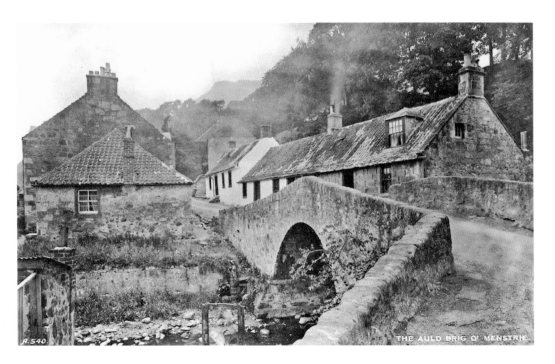

Menstrie, West of Old Bridge

The old bridge is located at the extreme northern end of the village on Ochil Road. The old picture postcard view sees us looking to the west from the bridge. Although the various cottages and houses in the area have changed over the last century, it is still instantly recognisable as the same location. The wall supporting the steps in the distance now form part of a supporting garden wall, while the whitewashed wall beyond that, under the tree, is still present today, but looking more natural.

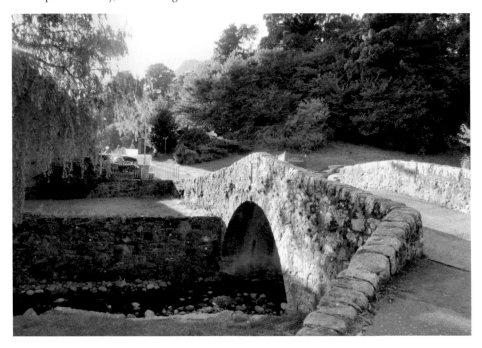

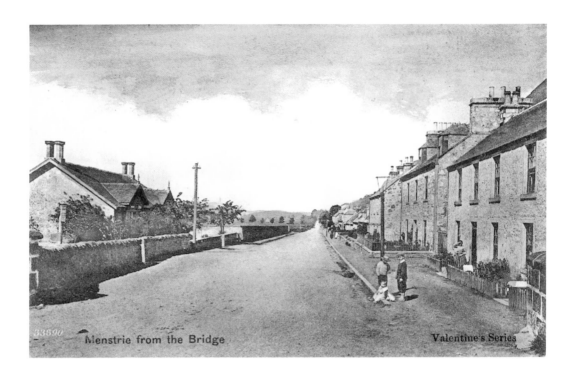

Menstrie from the Bridge

Menstrie from the Bridge

The major change between the two images here is that the block of houses on the right hand side of the old postcard image have been demolished and the area is now a vacant corner with a couple of benches for sitting. On the left hand side, the cottages with the rather distinctive chimneys were the home of local public house the Burnside Inn, which has now closed.

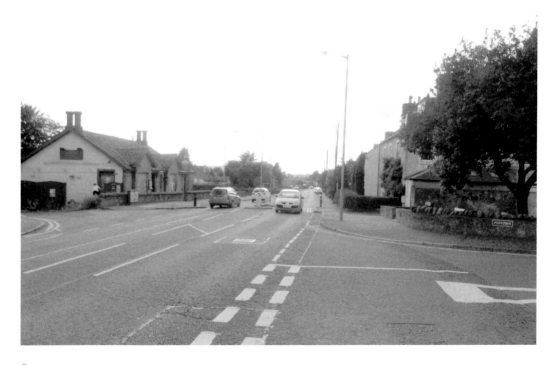

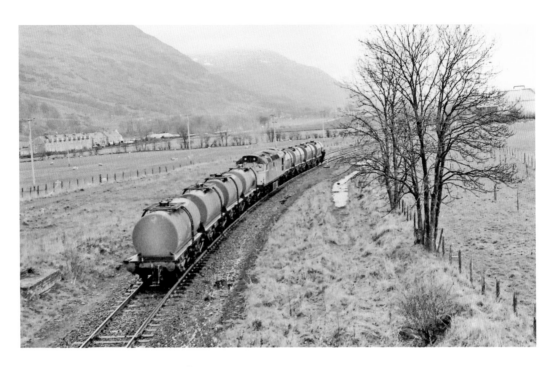

Menstrie, DCL Factory Train

A class 27 locomotive, number 27054, is seen in the older image in the middle of shunting molasses tank wagons near the Distillers Company Ltd factory on 24 April 1986. This rail link ceased to be useful, and by the mid-1980s it was closed. Today the track has been lifted and part of this short branch line is now in use as a walkway. This area was the location of Menstrie Station, but is now overgrown with weeds where the trees haven't taken hold.

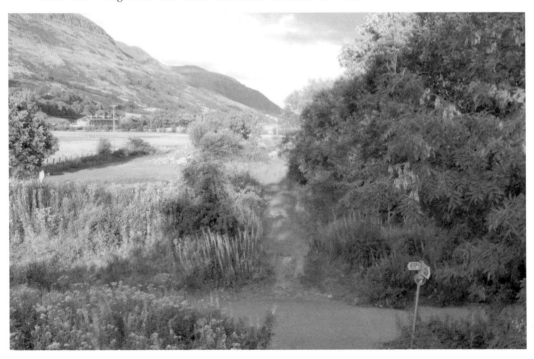

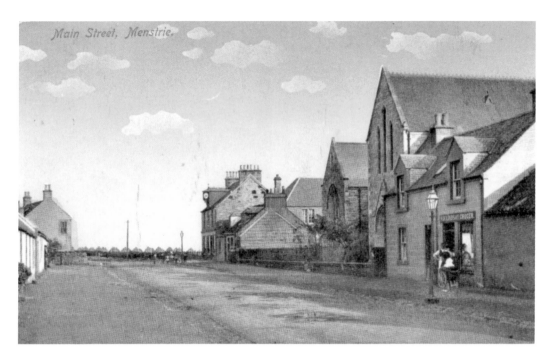

Menstrie, Main Street

Looking eastwards from a central location on the village's Main Street, we can see Menstrie Baptist Church, which has escaped any major changes over the last century. The grocery shop of W. H. Lindsay, seen on the right, is now a local takeaway while the retail shop in the distance is still adorned with its bi-directional clock faces. The single-storey unit has received an addition floor, but the main building work has taken place on the north side of the street. The whole area on this side of the street has been demolished and replaced with more modern housing.

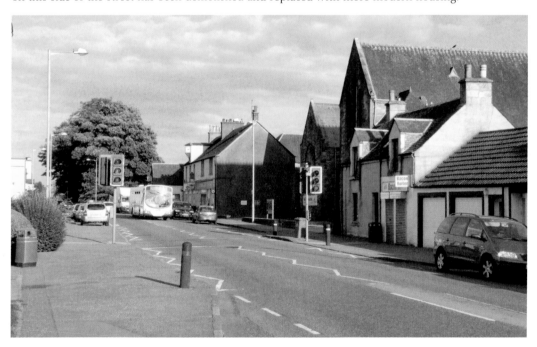

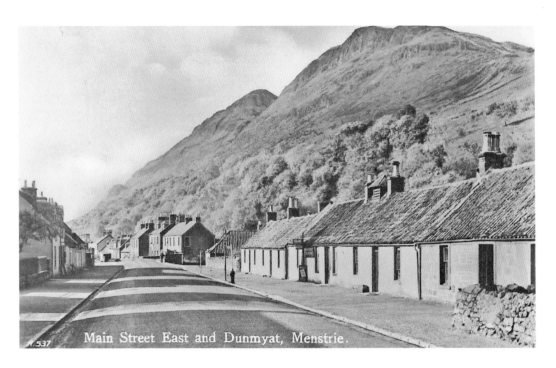

Main Street East and Dunmyat, Menstrie.

Menstrie, Main Street East and Dumyat

The old image is another picture postcard view looking to the west of the village from Main Street East. This view also shows the dominant Dumyat Hill, at the western extreme of the Ochil Hills. Unfortunately, the row of cottages on the north side of the road have never stood the test of time and the area is now part of Midtown Gardens, (now named the Nova Scotia Gardens), a small park with a modern sculpture known as the 'Fox Boy'.

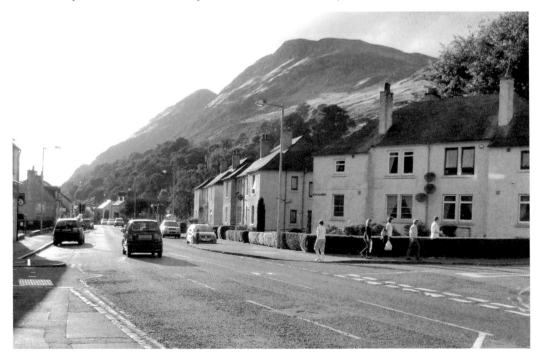

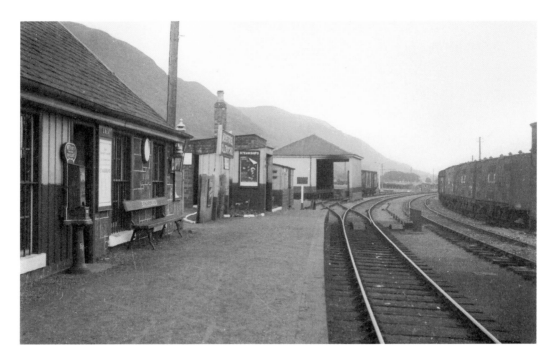

Menstrie Railway Station

In the early 1860s, a group of local mill and distillery owners got together to form the Alva Railway Company. This short branch line left the North British Railway's Stirling to Alloa line at a junction near Cambus, and ran through Menstrie to the terminus at Alva. The branch closed to passengers in November 1954, but the line stayed in use, serving the DCL factory until the mid-1980s. Today nothing remains of the station buildings, although a small section of the old platform is still there and is seen in the modern photograph.

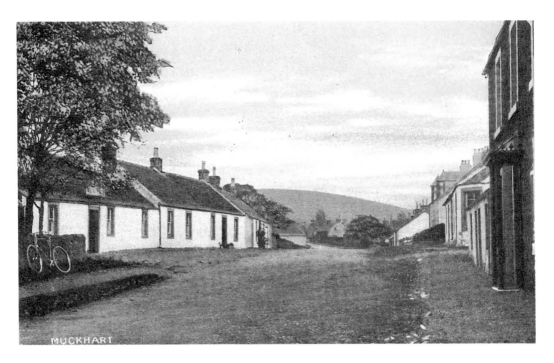

Muckhart 1

It was a pleasant surprise to find that the small cottages on the north side of the road had retained the white painted exteriors. Only the application of black painted window frames differentiated the cottages to the way they looked in the old postcard image, although this was by no means disappointing or off putting. They actually looked very pleasing to the eye and served to enhance the look of 'preservation'.

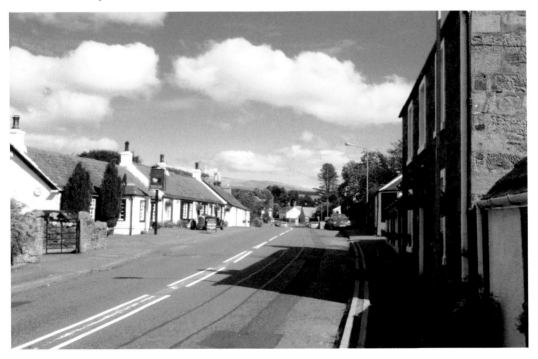

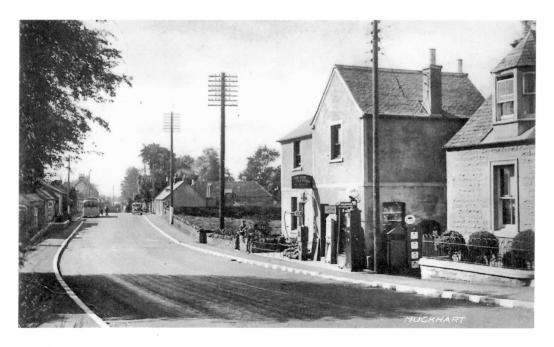

Muckhart 2

The building to the right of centre in the old postcard was called the Ochil Tea Rooms and appears to have also sold fuel to the local and passing motoring trade. The bus in the background seems to have attracted the attention of a couple of passers by, perhaps passengers from the adjacent car looking for directions. Nowadays, we can see that the former tea rooms are still in use, but now called Mona's of Muckhart coffee shop. The vacant land to the left of the tea rooms now has a farmhouse-style dwelling house built on it, in keeping with the style of the surrounding architecture.

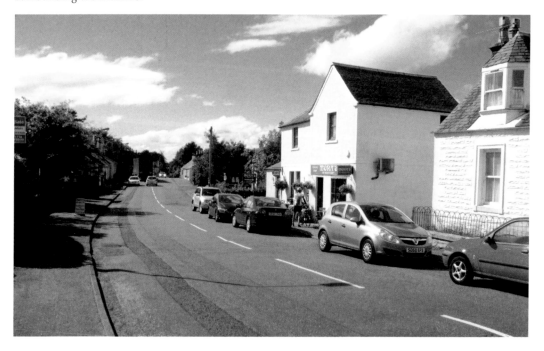

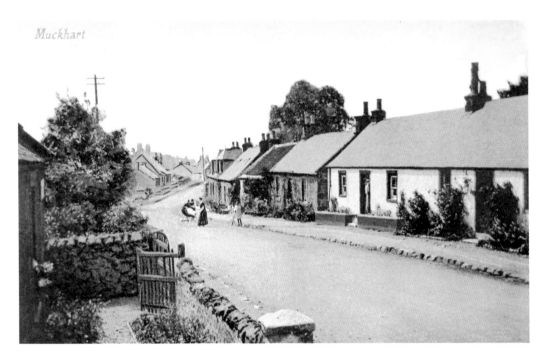

Muckhart 3

Even at the north-east of this lovely little village, looking southward, we find that little has changed here too. Similarly to the other small buildings throughout the village, the white exterior painted cottages have stayed true to form and look exactly as they did in the old postcard image. The only difference between the two images is to the door of the white cottage in the present day photograph, which has been bricked up.

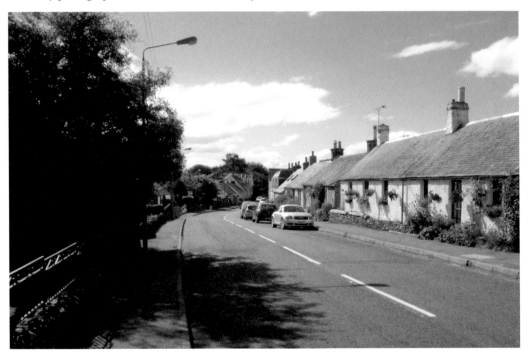

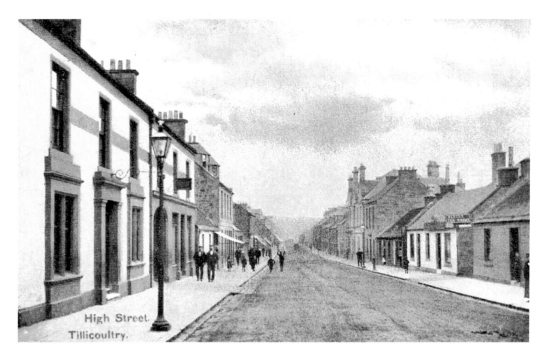

High Street.
Tillicoultry.

Tillicoultry, High Street

This was another one of the challenging locations that had changed so much I had to look two or three times to make sure I was in the same location. Only the building on the left hand side of the postcard, which looks like it may have been a public house or stables, and the building with the gable end showing on the recent photograph remain to link the two locations together. Today, the left hand building has now been converted into housing. One of the notices on the white building on the right of the old image is seen displaying an advert for Blacks Tea Rooms.

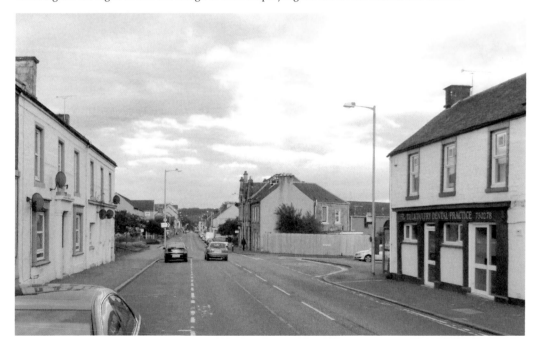

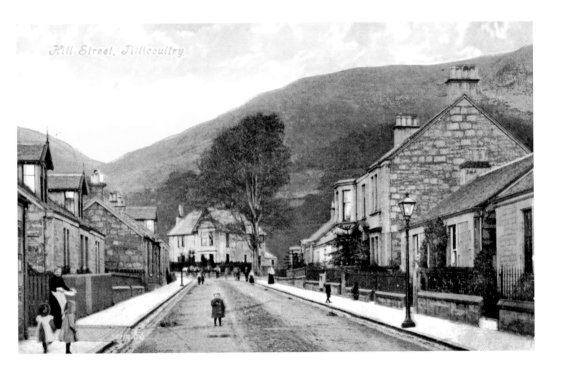

Tillicoultry, Hill Street

Not much has changed when comparing these two images of Hill Street taken almost a century apart. The only main differences are minor. The large tree at the top of the road has been removed, as have the original cast iron railings, but these have been replaced by smaller, less elaborate fences.

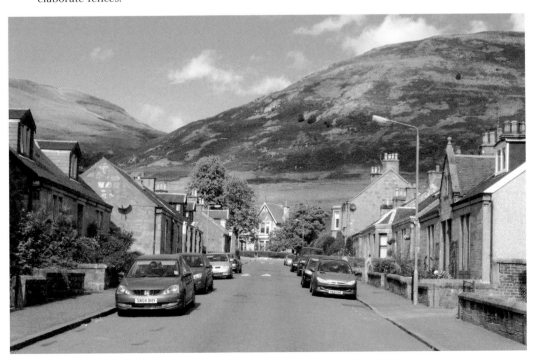

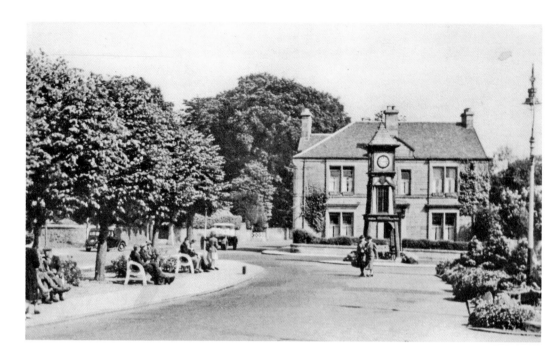

Tillicoultry, Murray Square 1

As surplus vehicle chassis were becoming more readily available after the First World War, bus companies began operating more frequent services in Tillicoultry, as they did throughout the length and breadth of the country. By the late 1920s, Provost Murray pressed the council to build a bus station after discovering that the eight bus services serving the town were providing 334 journeys per day. This would help reduce the number of accidents caused by the increase in traffic through the town.

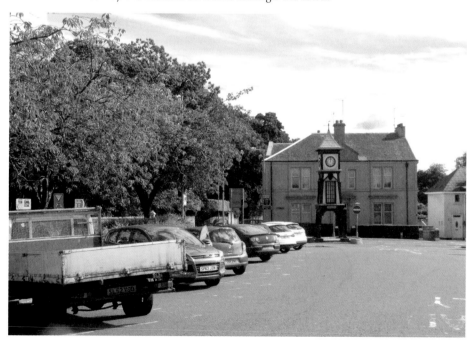

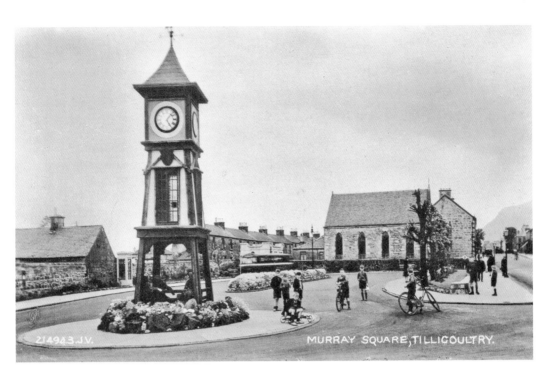

Tillicoultry, Murray Square 2

It was Provost Thomas Murray himself who donated the clock at the Moss Road end of the bus station, and in 1936 he also gifted the building known as 'the old man's howff', 'the Murray Howff' or the fantastically named 'Thomas Murray Howff for aged men'. It was a small reading room but unfortunately was demolished in 2001.

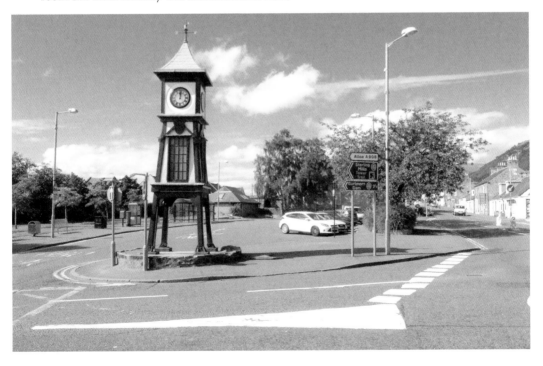

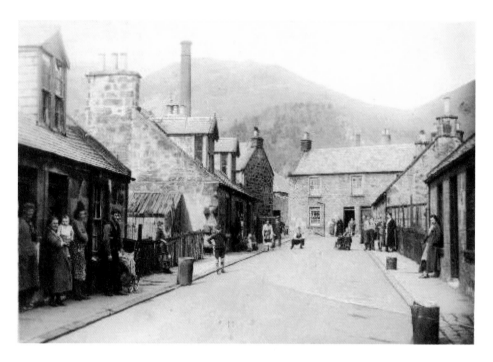

Tillicoultry, Park Street

What a total transformation as we compare images taken at the top of Park Street a century apart. I believe that the changes in this instance are definitely for the better as the older image shows how claustrophobic the street looked when the houses were built too close together. There are more modern cottages further down the street, built in the same style as the cottages seen on the left of the old photograph.

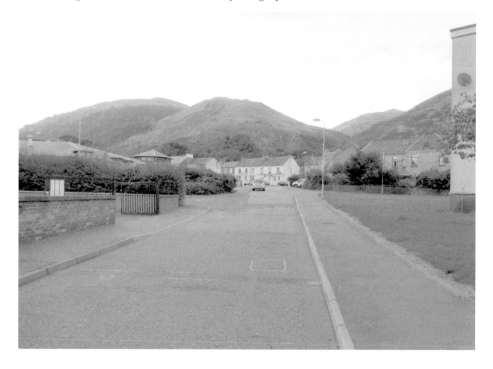

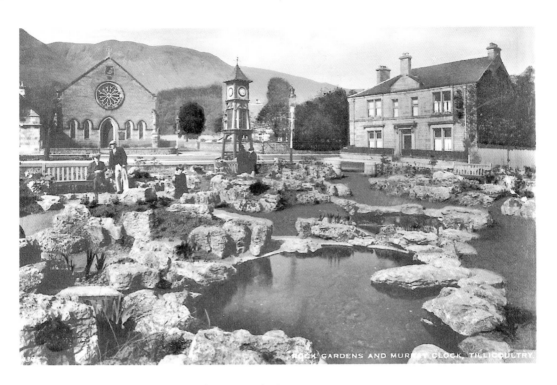

Tillicoultry, Rock Gardens and Murray Clock

This view has been taken from the south of Murray Square, in the location occupied by a beautiful little rock garden. There was also a rose garden in the vicinity and plants for both gardens were donated by Provost Thomas Murray after the bus station and gardens were built in the 1930s. Today, both the rock and rose gardens have been grassed over.

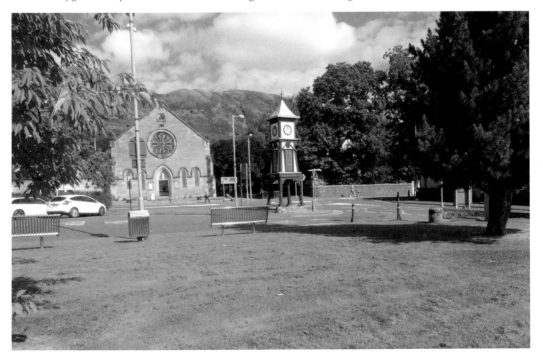

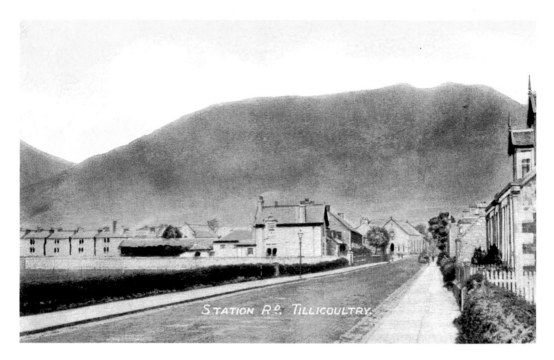

Tillicoultry, Station Road

The old picture postcard shows the road as being named as Station Road. This may have been the case at one time as Tillicoultry did have a station, further down this road. Nowadays, this location is called Moss Road as we are looking northward towards Murray Square and the church at the road end. Only a couple of the old cottages remain, but the area is now much changed thanks to the addition of more modern housing.